The Great

Beyond

Restoring women to their God-given role in the church

Richard Bradbury

PNEUMA SPRINGS PUBLISHING UK

First Published in 2018 by:
Pneuma Springs Publishing

The Great Beyond
Copyright © 2018 Richard Bradbury

ISBN13: 9781782284574

British Library Cataloguing in Publication Data. A catalogue record for this book is available from the British Library.

Pneuma Springs Publishing
A Subsidiary of Pneuma Springs Ltd.
7 Groveherst Road, Dartford Kent, DA1 5JD.
E: admin@pneumasprings.co.uk
W: www.pneumasprings.co.uk

Dedication

I am indebted to the following people who have encouraged me and given feedback to me as I have been on this journey.

To Christine Webb who always reads my manuscripts and points out any grammatical errors.

To Jo Hargreaves and Joy Blundell who encouraged me to write this book and who have given invaluable feedback along the way.

To my wife, Carolyn, who has never let her gender get in the way of her passion to serve God.

Finally, to my daughters, Katie and Emma, for whom I hope to leave a legacy of opportunity through this work.

Contents

Foreword

I remember hearing for the first time that my name was included in the Bible. This wasn't an intentional decision my parents made but it still felt full of heavenly intention to me as a brand new follower of Jesus secretly devouring the scripture in her university bedroom.

In the Gospels seven women are described using the Greek verb 'Diakoneo' which means to minister and to serve, these women followed Jesus, they served alongside him, listened to his truth and supported and provided for him.

I remember the sense of call, the sense of affirmation - I am included in the story, as a follower of Jesus, as Joanna, as a woman.

And then the exclusion.

I remember the conversation, it was almost a flippant throw away comment, something I already should have known if I had only read my Bible properly.

Did I not know? Had I not heard? Leadership is male.

There was no indignation on my part, simply a red face and a repentant heart, because no, I didn't know.

As a new believer I had read the Gospels and found myself in them. I had heard the words of Jesus and claimed them for myself. I had read of Deborah, Esther, Vashti and Rahab, I had pored over the accounts of Ruth and Naomi, Hannah and Huldah and felt galvanized by the examples of Mary, Martha, Junia, Priscilla, Lydia and Philip's daughters.

The Gospel's didn't look like patriarchy to me.

How was I to know that despite all of this, despite Jesus' radical inclusion of women I was now excluded?

Mine is a story of disappointment to reappointment but there are many more stories of exclusion and hurt, confusion

and heartache as women who are gifted to lead and to pioneer, to prophesy and lead movements are silenced, and excluded. As Maya Angelou wrote 'There is no agony like bearing an untold story inside of you.'

I can see the story changing; and books like this one help to change the narrative, not with a 'happily ever after' but through sound doctrine and a call to really look at scripture.

I love how Richard never once treats the Bible as a weapon wielding it to prove his point or to his advantage, instead he ushers us gently and intelligently towards the good news.

This good news of Jesus speaks of liberation and freedom, it cries out 'come and drink, there is room at the table for you and for me and for us all.'

It looks like taking your place and using your gifts, it looks like men and women standing side by side declaring 'Your Kingdom come'.

It is good news for our daughters and our sons because when men and women take their place everyone benefits.

This book is good news to me. Richard's words are thoughtful, intelligent and are rooted in scripture and steeped in sound theology.

My hope and prayer is that this book will continue a much needed conversation that will open up the floodgates for more women to take their place in the Body of Christ.

Joanna Hargreaves – Leader, Alive Church, Hykeham

26/03/2018

Introduction

I grew up as a complementarian. This was the generally accepted wisdom I received from those I looked to for guidance and teaching. I taught this notion as part of an understanding of submission and authority that flowed from the Godhead down into the church and into marriage. When Roger Forster brought out his book advocating women leadership, I joined with much of the conservative evangelical world to condemn such a notion. I also criticised the Church of England for ordaining women priests. I do not say any of this with any pride, simply to relate the position from which I have come.

One day, I was giving a talk on complementarianism to a group of women. At the end of the talk, one of the women asked, 'If I feel a call to leadership and believe I have the gifting to accompany it, where does that leave me?' I could not really answer and this response left me feeling that I was letting 50% (and more) of the church down through denying them a means of expression and a calling that could benefit themselves and the church. Furthermore, I began to ask myself, was I standing in the way of God's plan for individuals and for the church?

My problem was that, before I could solve this problem practically, I had to resolve it theologically. I could not (and cannot) throw out the teaching of scripture as this is foundational for all that we do as Christians. I am definitely not a revisionist. Perhaps my understanding of scripture was faulty? Perhaps we had missed something in our interpretation of some of the 'difficult passages'?

This began a quest in me to try and discover what the Bible actually says on some of these issues and to reset my doctrine and practice accordingly. My starting point was feminist theology, much of which you will encounter in this

book. Whilst not embracing all that feminists have to say on these issues and rejecting completely some of the extremes (such as the views and practices advocated by Mary Daly), exposure to such writings challenged many of my preconceptions and gave me new insight from the perspective of women.

Along this journey, I remember asking my own wife one day, 'Do you feel that I have restricted you or held you back in any way from becoming all that God has called you to be?' She was gracious enough to answer that I had not, however, I remained with a sense that, for some, I had been a cork in the bottle which had prevented them from being free to enter into the fullness of their destiny. From that time, I have sought to release and support women in whatever ministry God has called them to.

The title of this book is 'The Great Beyond' (another REM song title). I chose it because it suggests a new way of being church together as men and women and it beckons us forward towards a yet-to-be-realised world. A place where '...in Christ Jesus you are all children of God through faith...There is neither Jew nor Gentile, neither slave nor free, nor is there male and female, for you are all one in Christ Jesus' (Galatians 3:26-28).

In the remainder of this book I will investigate the teaching of the Bible with regard to gender. Beginning with feminist criticism of the churches' teaching regarding women, I will consider what the Bible actually teaches about male and female roles and relationships. I will give consideration to the women of the Bible and see how a new perspective on their inclusion can change our understanding of male and female roles. Finally, I will try and give some practical suggestions as to how these things should work moving forward.

For the women who read this book, I apologise in advance for any vestiges of misogyny that still lurk within me and have come out in my writing. For the men who read this book, I would encourage you to lay aside your preconceptions and approach this book with an open-mind and heart in order to find out what the Bible actually teaches concerning men and women and their respective roles in the kingdom.

I am sure not everyone will agree with everything I say in this book. That is ok. I hope and pray that we can remain friends and partners in the gospel nevertheless.

Richard Bradbury

Chapter 1

A Feminist Perspective

Introduction

"Women are the weaker sex," so the old saying goes. Weaker some of them may be in terms of physical strength, but my experience of women is that they are far from weak. The picture we have inherited of women as a species over centuries, perhaps thousands of years, is of a breed of people quite different from men. Even today, we have books produced, such as *Men are from Mars. Women are from Venus,* by John Gray, which reinforce gender stereotypes and that have their roots, as we shall see below, in the philosophies of Greek misogynists.

We grow up with an image of women as being complex emotional beings who work by feelings and not by reason. They are instinctive and irrational, intuitive and unreasonable. They are more easily able to express their feelings, more willing to talk, more able to extend care for others, and more attuned to the spiritual side of life. In contrast, men are portrayed as stoic, goal orientated, rational, logical, aggressive, dominating, competitive and out of touch with their emotions.

Whatever the truth of such characterisations of men and women, they are certainly not universal. I would even suggest that many of them are formed because of the structure of society that forces us to play certain roles and act in certain ways that may not be 'natural' but become expected of us. Such roles and characteristics are reinforced

through novels, films, the media and through social conditioning. The role we are allowed to play governs how we respond in situations. Further, where the structures in which a person exists force them to behave in certain ways, the frustration associated with the situation will produce in them behaviours quite different from those not subjected to the same frustrations. Thus, many of the characteristics and behaviours associated with being female arise out of living in a male-dominated society which has suppressed and confined women whilst placing upon them stereotypical ways of being.

The feminist movement has identified and challenged many of these areas of society, however, the gender stereotypes / caricatures are still rife and continue to be reinforced through many of our power structures, literature, films, and way of living in the West. These have extended to the church which has, for the last 2,000 years, suppressed women and kept them from positions of authority and leadership, and largely silenced their theological voice.

There has been much written by feminist theologians regarding the restrictions and prohibitions women face in terms of developing their ministry within the church. However, much of this writing has been in academia and little of it has filtered through into the evangelical world, and particularly into New Church thinking. In this chapter, I will highlight the key issues that have been identified in such writing and reflect on them as they come up against our praxis in the New Churches.

In the outline below, I will present the issues as perceived by feminist theologians. This is to gain an alternative understanding rather than approaching the issue through our own preconceptions. It is not to say that all of these perceptions are correct in themselves. Fundamentally, the majority of feminist theologians approach scripture with a

hermeneutic of suspicion. As evangelicals, our hermeneutic must begin with the fact that scripture is the word of God. That does not mean, as we shall see, that the issues raised by feminists are not real and valid, but that they too need to be held up against the light of scripture, which we will endeavour to do as we proceed through this book.

Feminism and Scripture

Nicola Slee identifies the key principles behind feminist theology. Firstly, she recognises 'the structural injustice of sexism' which has as its key feature 'a pervasive dualism which makes a sharp distinction between perceived male and female roles, psychic qualities, characteristics and areas of responsibility, valuing those identified with the male as inherently superior to those identified with the female.'

Further, characteristics of this structural injustice are androcentrism (the practice of placing a masculine point of view at the centre of one's world view, culture, and history, thereby culturally marginalizing femininity) and patriarchy (the domination of power structures by males).[1] Therefore, 'feminist theology attacks the idolatry of the *male* God [italics hers] that supports the ideology of patriarchy'.[2] In other words, feminist's perceive that God has always been recognised and worshipped exclusively in male terms and this has tended to underpin patriarchy whilst marginalising the female perspective and attributes.

This has its outworking in feminist theologians critiquing scripture, doctrine, ecclesiastical structures, religious language and anything that reinforces male domination and

[1] Nicola Slee, *Faith and Feminism: An Introduction to Christian Feminist Theology*, (London: Darton, Longman and Todd Ltd., 2003), pp.3-4

[2] Rachel Muers, 'Feminism, Gender, and Theology' in *The Modern Theologians: An introduction to Christian Theology since 1918*, Eds., David F.Ford with Rachel Muers (Oxford: Blackwell Publishing Ltd., 2005), p.433

oppression of women. It also seeks to bring a woman's perspective in all of these areas.

This androcentrism and patriarchy is not limited to the church. Indeed, the whole basis of feminism is that these perspectives are ubiquitous in the Western world as a whole. The feminist movement has sought to challenge and break these attitudes in order to enable women to find their place in society, not on the basis of traditional philosophies, structures and practices, but rather on the basis of being human and equal to men in every way.

For feminists, all theology and practice has been based around the notion of God as male, and this has tended to isolate and ignore the feminine aspects of God and how that works out in faith and practice.

The second principle Slee identifies is 'the grounding of theology in women's experience', stating that 'most theology in the past has been done almost exclusively from the perspective of male experience'.[3] Linda Woodhead identifies that 'most feminist theologians make the empiricist claim that all knowledge is ultimately based upon experience' and that 'religion comes *after* [italics hers] experience'.[4] She suggests that this claim is made of language too and so, as feminists propose that language imposes its meaning and symbols on experience, religion imposes its structures, language and symbols on spiritual experience, and is therefore open to critique.

By 'women's experience' here feminists are referring to the way life is experienced as a woman in a patriarchal world which is oppressive to women by maintaining them in a subordinate role and with a set of characteristics which are

[3] Slee, *Faith and Feminism*, p.5

[4] Linda Woodhead, 'Spiritualising the Sacred: Critique of Feminist Theology', in *Modern Theology* 13, 2nd April 1997, pp.191-212 [pp.197-198]

binary opposites to those of the male. In addition, since a woman's experience of faith and practice has been largely ignored by theologians and the church, such theology and practice are incomplete and limiting for women.

The third principle Slee identifies is that of 'listening and looking for difference'. As Bridget Gilfillan Upton suggests, 'patriarchal cultures have subsumed the female under a male norm – to be human is male: to be female is a derivative.'[5] However, whilst most of the early work of feminist theologians was completed in 'white middle-class backgrounds in Europe or North America', feminist theology now embraces the differences in the 'multiple variations of gender, race, culture, class and sexual orientation' to be found across the world, 'all of which affect the reading of the text'.[6] Thus, even though feminist theology is approached from the perspective of women's experience, every woman's experience is different and that will affect the process and conclusions. [7]

Thus, from a feminist perspective, maleness is the dominating cultural form of the church and theology and everything female is seen as derivative and 'other'. Male is normal; female is abnormal. Male is rational and reasonable; female is intuitive and unreasonable. The result is that doctrine and practice, dominated by men, has tended to subjugate women and their perspective and not allowed their voices to be heard.

The fourth principle Slee identifies is the 'commitment to liberating and empowering women' – that theology 'arises directly out of life experience and must flow back into

[5] B. Glifillan Upton, 'Feminist theology as biblical hermeneutics', in *The Cambridge Companion to Feminist Theology*, ed. by

S. Frank Parsons, (Cambridge University Press, 2002), pp.97-113 [p103]

[6] Ibid., p.103

[7] Slee, *Faith and Feminism*, p.6

experience'.[8] In other words, the theology undertaken must result in undoing the oppression identified and bring about the 'liberation and empowerment of women'.[9]

Thus, in considering the experience of feminist theologians, three elements are identified: the embodied location of the theologian, her desires, and her suffering. In other words, theology will be shaped by the gender, location, experience and longings of the specific theologian, and this uniquely female experience of faith as women encounter it must flow back into the faith and practice of the church as a whole.

Essentially, these three elements (embodied location, desires and suffering) make up the experience of the theologian, and experience, specifically, women's experience, is the 'touchstone' by which feminist theologians critique Christianity.[10] Woodhead goes on to identify that 'the key women's experience is oppression, and that the basis of a feminist critique is therefore a rejection of oppression (sexism) and a commitment to liberation'.[11]

This oppression of women is identified at all levels of society, religion and culture. Specifically, with respect to Christianity, the issue for feminists is that 'every stage of biblical interpretation in the West has been characterised by patriarchal power structures and patriarchal texts, from translation to reading to preaching and praxis within conventional structures'.[12] In other words, the Bible comes out of a patriarchal culture, was written by and has been interpreted by men from within patriarchal ecclesiastical and academic structures and therefore has 'tended systematically to silence women and to lend ideological support to their

[8] Ibid., p.7

[9] Ibid., p.7

[10] Woodhead, 'A Critique of Feminist Theology', pp.197

[11] Ibid., p.198

[12] Glifillan Upton, 'Feminist Theology', p.99

oppression'.[13] Bridget Gilfillan Upton identifies that it was Elizabeth Cady Stanton who began the investigations into what was perceived as a 'misogynist religion,' which subsequent feminist theologians have continued.[14]

The identification by feminist theologians of oppression as the key to women's experience opens up the notion of 'difference' referred to above. Whilst it is affirmed by feminist theologians that all women, everywhere have a shared experience of oppression through male dominated structures in society, religion and culture, the forms and consequences of that oppression vary dependent on the 'embodied location' of the individual woman.[15] The oppression experienced by women in Western liberal democracies will be different to that experienced by women elsewhere. Slee suggests that 'women in different cultural contexts face very different social challenges, whether this be issues of female circumcision, the status of dalits in India, or women's experiences of 'han' (unrequited suffering) in Korea, as well as broader shared issues of colonisation, enculturation and poverty caused, at least in part, by western domination and exploitation'.[16] This difference has been recognised through the work of such women as Mercy Amba Oduyoye and has given rise to such refinements as Womanist theology, which claims to be 'a distinctive form of black feminist theology'; Mujerista or Latino theology, Minjung or Korean theology, and Indian Dalit theology.[17]

For all of these theologies, the desired outcome is the liberation of women from all forms of oppression, but the emphasis of that liberation will vary. For example, for

[13] Muers, 'Feminism, Gender, and Theology' p.431

[14] Glifillan Upton, 'Feminist Theology', p.98

[15] Muers, 'Feminism, Gender, and Theology', p.437

[16] Ibid., pp.10-11

[17] Slee, *Faith and Feminism*, p.11

African women, 'Liberation refers to Africans' urgent need to strive for economic and political freedom from neo-colonialism, the control of the World Bank and the International Monetary Fund, and the ruthless exploitation of the poor who are struggling for basic necessities for survival'.[18] Kwok goes on to describe a lecture given by Oduyoye at Yale University in 1996 in which she identified, in contrast with Mary Daly and Alice Walker, that genital mutilation is not the key area of oppression for African women but rather that 'survival and economic justice' are 'the primary issues'.[19] Thus, the 'embodied location' of the feminist theologian influences profoundly the analysis and desired outcome of the individual with respect to what liberation entails, and this in turn influences their theological approach.

Current religious, cultural and economic structures associated with patriarchy also restrict the fulfilment of desires and reinforce the suffering of women across the world. Continuing with African theology for a moment, Kwok suggests that 'to reclaim that they are subjects in charge of their own destiny, African women have to fight against patriarchy in their traditions on the one hand, and the complex legacy of colonialist feminism, on the other'.[20] This is not a 'one size fits all' African approach. Throughout Africa there are variations in culture, tradition and in religious expression, and each of these must form part of the theological process for the individual's theological interpretation. This gives rise to 'cultural hermeneutics' which 'enables women to interpret their experiences and realities' and thereby work for liberation within their

[18] Kwok Pui-Lan, 'Mercy Amba Oduyoye and African Women's Theology', *Journal of Feminist Studies in Religion*, 20 no 1 Spring 2004, pp. 7-22 [p.9]

[19] Ibid., p.11

[20] Ibid., p.8

context, bringing the possibility of fulfilling desires and relieving suffering.[21] This cultural hermeneutic can equally be applied in the other distinct cultural feminist theologies identified above.

The interpretation of experiences and realities for the individual theologian give rise to a message which is indeed 'good news' to the poor and the oppressed of the culture in which such a message is received. In other words, the message incorporates liberation from all forms of oppression and does not ignore the social, cultural, political, economic oppression confronted by the recipient of such good news. Crucial to this good news is a Christology which sees Christ as 'a friend and confidant, a co-sufferer who shares and bears women's pain, and a healer and provider as well as a liberator'.[22] Such a Christology is strongly contextual and sees Christ as 'the power and compassion of God to resist and overcome oppression'.[23]

Similarly, Rosemary Radford Ruether presents a Christology which strips Jesus of his Messianic or divine Logos epithets and instead presents him as 'an iconoclastic prophet who proclaims the reversal of the social order'.[24] For Ruether, Jesus is he who 'practices solidarity with the poor and speaks of their priority within the Kingdom of God'.[25] Thus, he is a liberator of the oppressed, and feminist theologians are continuing his work of salvation when they work to undo oppression of all forms and bring about liberation.

Thus far in this chapter, we have identified the main principles of the feminist approach to theology.

[21] Ibid., p.15

[22] Slee, *Faith and Feminism,* p.58

[23] Ibid., p.58

[24] Grant D. Miller Francisco 'Ruether, Rosemary Radford', Boston Collaborative Encyclopedia of Western Theology (1999), <http://people.bu.edu/wwildman/bce/mwt_themes_908_ruether.htm> [accessed 02/02/2012], pp.3-4

[25] Muers, 'Feminism, Gender, and Theology', p.441

Fundamental to this is the notion that, apart from the exposure of androcentrism and patriarchy, the key hermeneutic for feminist theology is women's experience, particularly the experience of oppression within a given cultural, religious, political or economic context.

In critiquing the feminist approach, Linda Woodhead does raise a 'suspicion' that 'many versions of the feminist critique do in fact involve very large scale commitments, commitments to an entire world view or spiritual system which is incompatible with Christianity,' which results in 'weighing up Christianity against an externally imposed, externally derived and unquestionable standard'.[26] She identifies the basis of feminist critique as 'the Enlightenment project' which has arrived at 'a foundational standard by which to judge the truth and worth of all traditions', and she goes on to state that 'Christian theology has never been constructed on the basis of 'experience'. Rather it has been constructed on the basis of encounter with God in Christ mediated through the Christian tradition'.[27] This seems to be the major point of departure for many feminist theologians. Based on this foundational critique, Radical Feminists, such as Mary Daly, have rejected all Christian tradition, and have sought to replace it with something new, seeing Christianity as irredeemable.[28] In contrast, reformist feminist theologians, such as Rosemary Radford Ruether and Sallie McFague, 'recognise the liabilities and potentialities of the Christian tradition' but seek to reform it from within.[29] In a post-modern world, the basis of this critique, as identified by Linda Woodhead, is not without its

[26] Woodhead, 'A Critique of Feminist Theology', p.196-7

[27] Ibid., p.200

[28] Patricia Wilson-Kastner, 'Christianity and New Feminist Religions', Religion-online database (09/09/1981),

<http://www.religion-online.org/showarticle.asp?title=1722> [accessed 02/02/2012], p.2

[29] Rolf Bouma, Bouma, Rolf, 'Feminist Theology: Rosemary Radford Ruether / Sallie McFague', Boston Collaborative Encyclopedia of Western Theology (1997),

http://people.bu.edu/wwildman/bce/mwt_themes_907_ruethermcfague.htm [accessed 02/02/2012] p.2

problems.[30] The influence of Womanist and other non-Western theologies has identified that feminist theology must be contextual if it is to be meaningful and result in real liberation for those who are oppressed and thus be 'good news to the poor'. It seems to me that this is true for all cultures, including that of the UK in 21st Century.

In 2012, coverage was given in the News of Katy Price attending and winning a feminist debate against Rachel Johnson at Cambridge University, supporting the proposition that women are not successful in their careers because they lack ambition and put family first. In other words, women are complicit with the patriarchal expectations and structures within society, and these restrict their progression to positions of power, authority and wealth. The irony that a woman who has used her female form and played to male fantasies to gain fame, power and wealth, has become a 'role model' for many young girls to do the same, and now has championed a feminist cause in academia, perhaps without understanding the real issues at stake, leads me to suggest that in the post-modern world, the feminist endeavour needs to re-engage with popular culture in order, not just to undo patriarchal oppressive structures, but to help women to recognise that liberation is a responsibility as well as a goal. If Western feminist theology is to be effective in bringing about change, it must move outside of the hallowed halls of academia and engage with the market place, the street and the women who occupy both of those locations, in order to present itself in a form that is accessible, thus to contextualise itself in the real world of real women. This is no less important for the UK as it is in Africa, India or Latin America.

[30] Woodhead, 'A Critique of Feminist Theology', pp.199-200

Conclusion

Within the target audience of this book, the culture we inhabit is the evangelical / charismatic world of the New Churches. For the most part, this world is instinctively conservative in terms of interpreting scripture with any resultant change in culture flowing from such interpretation. This has led to a theology that has been reluctant to revisit inherited norms and change accordingly. That is not to say that we should 'throw the baby out with the bathwater'. Where theological principle is at stake, the Bible wins every time. However, we have been reluctant to revisit these themes, not with a 'hermeneutic of suspicion' as feminists adopt, but rather with a hermeneutic of honesty that seeks to find out for certain what the Bible actually teaches, rather than taking the words off the page at face value without any real attempt to interpret them for our own context.

The result of this reluctance is that we have continued the patriarchal oppression of women within our churches, not allowing them to rise to their God-ordained and God-gifted positions amongst us. Women in the new churches have also been complicit in this by not challenging the status quo enough. However, the blame for this continued oppression lies mostly with the male leadership that has often seen 'strong' or 'forceful' women as a threat or attributed to them a 'Jezebelic spirit' (see Chapter 6 below).

In the remainder of this book, I will attempt to give an honest interpretation of the Bible which takes into account the very real oppression of women that has taken place over the last two millennia, whether intentional or otherwise. This will mean revisiting some of the 'difficult passages' as well as seeking to identify the sweep of the whole of scripture with respect to women. It will also mean seeking to understand what the New Covenant really means for a person regardless of gender. This brings us to our next chapter in which we will begin to explore gender and sexuality.

Chapter 2

Gender

Introduction

In touching on this subject, I am conscious that I am entering into a very current debate concerning what constitutes our sexuality and gender, particularly as it affects the LGBT[31] community. That is not the focus of this book and I have written on that subject elsewhere. Instead, I am concentrating here on what makes us male or female. Is the difference biological or / and psychological, or is it simply a social construct? Thus, the focus of this chapter is on gender and not sexual orientation.

Defining Human Gender

In research I carried out through interviewing various women in positions of authority in the church, it was identified that there was a universal acceptance on the part of the respondents that women and men are different. This difference, in the view of the respondents, was not limited to genitalia but also related to a set of characteristics that typified female and male attributes respectively leading to the suggestion of 'a complementarity of the genders'.[32] To clarify here, writers on this subject identify our sex as a product of our genitalia, but our gender as a product of the characteristics that define us as people.

[31] Many attribute additional letters to this acronym such as 'I' or 'e'. For the sake of simplicity, I have used the simple form of the acronym here.

[32] E. Graham., *Making the difference: gender, personhood and theology* (London: Mowbray, 1995), p.12

The notion of gender as a social construct was not suggested by the respondents; rather 'a gender-polarising link between the sex of one's body and the character of one's psyche and one's sexuality' was assumed.[33] Thus, it was affirmed by all respondents that there were certain feminine characteristics that arise out of the mere fact of being female (i.e. with female genitalia), and masculine characteristics that arise out of the mere fact of being male (i.e. having male genitalia).

Instinctively, the respondents constructed 'an indices of 'masculinity' and 'femininity''.[34] This 'biological essentialism' seems to be an assumed universal reality, at least amongst the sample population I interviewed, and is perhaps part of the 'false universalist claims relating to all women or all human beings'.[35] As Elaine Graham says, 'so long as 'femininity' is defined as the polar opposite and negation of dominant and normative 'masculinity', it is still founded on a pattern of gender traits that are fundamentally asymmetrical' and is no 'more than the recycled projections of patriarchal objectification'.[36]

The fundamental question we are going to explore in this chapter is whether it is legitimate to typify femininity and masculinity by a set of binary characteristics which then impose expectations and roles on women and men respectively. Alternatively, is there a different way of identifying gender that will overcome patriarchal expectations and the male objectification of women?

Biological Differences and Traits

Without doubt, there are biological differences between men and women which define for us particular roles in the

[33] Ursula King, *Religion and Gender* (Oxford: Blackwell Publishers, 1995) p.8

[34] Graham, *Making the difference*, p.17

[35] King, Religion and Gender, p.12

[36] Graham, *Making the difference*, p.47

procreation and nurture of children. From earliest times, these differences demarcated for women and men specific social tasks – men were hunter gatherers and women were children nurturers. Around these roles, a whole variety of domestic duties were assumed by both genders.

As society moved from a hunter-gatherer to a more agrarian society, communal living placed upon the burgeoning cities responsibilities for collective management, which included laws to govern society, and gave rise to forms of power structure to ensure safety and good order for all citizens. From early times, these power structures were male dominated. Thus, from the commencement of society, what it is to be male or female has been defined from within these power structures and by the assumed domestic roles of males and females such that no definition, and no person's experience, is neutral. Thus, defining explicitly female or male traits or characteristics is notoriously difficult. The roles we play within society are a social construct which flows out of our biology. However, these roles do not in themselves enforce a set of binary characteristics that can be identified as male or female.

Plato and Aristotle both tended to identify male and female gender in a dualistic manner. 'Prudence Allen argues that the Greeks characterised the relative differences and similarities between women and men as operating at a number of levels: ontological status (the substance of basic human nature); reproductive function; and intellectual and moral qualities'.[37]

As Greek philosophy was subsumed into Christianity (Plato and Aristotle were fundamental to the development of much theology in the first 1500 years of the church), so the notion

[37] Prudence Allen, *The Concept of Women: the Aristotelian Revolution 750BC-AD1250* (Montreal: Eden 1985), quoted in Elaine Graham, *Making the difference*, p.12

of males and females as 'discrete and separate beings predominated'[38]. This thinking has dominated theology and praxis for most of church history and has only recently begun to change as it has been challenged from within the perspective of feminism.

So, are there a set of characteristics that define what it is to be a woman and a set of characteristics that define what it is to be a man? If there is such a set of characteristics, are they automatic, based on our biology? This binary approach has been dismissed by most researchers into gender in modern times. However, this notion of complementarity is fairly ancient. Plato and Aristotle both viewed males and females as discrete and separate types of beings. Heraclitus suggested males and females were polar opposites. Pythagoras identified a list of binary characteristics which comprise males and females as follows:

Male / Female

Culture / Nurture

Straight / Curved

Reason / Intuition

Public / Private

Humanity / Nature-Animality

Production / Reproduction

Subject / Object

Self / Other

Odd / Even

Universal / Particular

Mind / Body

Civilized / Primitive

Good / Bad

Master / Slave[39]

A cursory look at this list tells us that to be female is derivative of and subordinate to the male. That was certainly how Aristotle saw the world with his notion of the female as the "misbegotten' male, a departure from true human essence'[40].

Whilst Paul championed the equality of both genders (see chapter 4 below), the Early Church, in order not to cause offence and bring the gospel into disrepute, reinforced the household codes that were to be found in the writings of the Greek philosophers, although with a distinctly Christian slant. However, as the influence of Greek philosophy in the formulation of Christian theology increased, so did the notion of the inferiority of women. By the time Thomas Aquinas was writing, this inequality was assumed: 'he believed that females were defective males, developing as such when conditions *in utero* were unsatisfactory for the full development of male humanity'[41].

These notions of specific characteristics associated with women and the inferiority of women have dominated western thought and practice at all levels, from the positions of power and authority attainable, right down to the roles each fulfil within society. These concepts have also been the controlling influence on how the church has viewed and accommodated women. Whilst much has been done in the last two hundred years to begin to address this, beginning with the work of Mary Wollstonecraft and others, there

[39] Ibid., pp.12-13

[40] Ibid., p.14

[41] Ibid., p.14

remains a default mindset that continues to view the role of women through this filter.

More recent scholarship has identified a difference between sexuality and gender such that sex is a factor of internal and external genitalia, whereas gender is 'psychological and cultural'.[42] Rather than being a factor of binary opposites, the gender of an individual is seen as being made up of factors from anthropology, psychology, biology, sociology, history, philosophy and culture. Thus, gender is a complex mixture of factors that operate within an individual. Sexual identity is spoken of in terms of male and female and gender in terms of masculine and feminine.

The question being asked here is what exactly characterises a woman or a man? If it is more than our genitalia, is it in our essence – our very being – or is it a social construct that arises as we develop? Does being born a man or a woman guarantee that I will have a certain set of characteristics that will define me? Certainly, levels of oestrogen and testosterone in us will influence our behaviour but are our characteristics themselves determined by psycho-social factors in our upbringing or by something more intrinsic?

Post-modernist thinking has taken this one step further by suggesting that the gender of each one of us is unique to us and can be constructed in any way we choose based on what feels 'true' for us. This has given rise to the current emphasis on making room for people who feel they have a gendered identity that does not conform to the sex of their body. Hence, the stress on allowing and encouraging people to transition from one gender to another in terms of their body so that it aligns with their psychological gender.

But aren't we just playing to gender stereotypes in supporting this? If what it means to be male or female does

[42] Robert Stoller, *Sex and Gender* (New York: Science House, 1968)

not arise from a list of binary differences, how can we know what it 'feels' like to be a man or a woman? This is all suggested around how we imagine a man or a woman to feel, or how we expect them to feel and act based on a list of external criteria which may or may not be rooted in reality.

A further factor here is that if I am free to choose my gender based on how I feel against a list of binary characteristics, my self-designated gender may not be the determiner of my sexual orientation. I remember hearing Eddie Izzard, who of course is a cross-dresser, describe himself as a lesbian in a man's body. Thus, he likes to dress as a woman but still finds women sexually attractive. This is, to say the least, confused.

I know, for myself, I do not conform to the gender stereotypes. On the one hand, I like mountain climbing, sport, gym-work, military history, action movies, motor bikes and many other things associated with stereotypical / caricatured masculinity. On the other hand, I have a love of the arts: ballet, Shakespeare, romcoms, musicals, poetry – I have read all of the Jane Austen books and loved them – I am rational and intuitive. I am brave and yet sensitive. I don't fit into either group of categories and yet I consider myself complete as a person in every sense of the word. I am who I am. My identity is in Christ. How I feel and act flows out of that and, whether I exhibit 'masculine' or 'feminine' characteristics is immaterial. My genitalia define me as a man. My character defines me as unique and made in the image of God. This definition is not about conforming to a set of binary characteristics outside of myself but of being who I am.

This brief study informs us that the determination of sex and gender is a very complex area of investigation. However, our current obsession with encouraging freedom of expression and self-determination in terms of identity, has given rise to

the contemporary situation which is now encouraging children as young as six to self-identify their gender and transition from male to female or vice versa as they choose. If gender is a social construct, then the sex of my body is a given regardless of how I feel in relation to it. The whole notion of 'feeling like a woman' or 'feeling like a man' is suspect since it is based on this Greek idea of binary opposites which itself is based on a suspect view of male supremacy.

So, the question remains, are there characteristics that are specifically female that either equip or prohibit her from being a leader, or are all such classifications simply a social construct? If there are such exclusive characteristics attributed to males and females, which flow out of our being made in the image of God, then we need both perspectives in order to fulfil the divine mandate given to humanity. If there are no such differences arising simply out of our gender, then there should be no restrictions on the role each can perform.

Where, perhaps, there is a difference between the genders, taking into account Graham's summary of the varying models of the combination or otherwise of 'nature / culture', is in the 'distinctiveness of women's experience'.[43] It is the experience of women in a patriarchal society, which has shaped or honed or contributed to particular characteristics that can bring a different dimension to ministry. Of course, this also is not a universal as it is influenced by economic factors, ethnicity, culture, geographical situation, and so forth, as we saw in chapter 1. It is also problematical to identify specific gender-related characteristics on this basis. However, for the moment, inclusion of both men and women in leadership roles regardless of difference can perhaps start to bring wholeness to the leadership of the

[43] Ibid., pp.77-98, p.44

church, not on the basis of 'the Thomist notion of subordination and inferiority', but rather 'from an anthropology of equivalence and mutuality'.[44] It is this equivalence and mutuality that will truly represent the Godhead in that it will bring together all the characteristics that God gave to Man and Woman to 'rule' over the earth (Genesis 1:28). Certainly, we need all of those characteristics in our leadership of the church.

So, we return to the question, are there character traits that are distinctively female or are these a social construct that has been created out of a patriarchal society? Research suggests that is difficult to be definitive about this. Either way, none of these 'traits' in themselves should determine the role a woman can or can't play within the church. Our role or ministry should not be not determined by our genitalia but by the gifting and calling of God.

If there is a deeper spiritual principle to determine such a role then that is something we will have to consider and we will contemplate this in chapters 3 and 4 below.

[44] Ibid., p.47

Chapter 3

Made in God's Image

Introduction

Linda Woodhead identifies that 'the key women's experience is oppression, and that the basis of a feminist critique is therefore a rejection of oppression (sexism) and a commitment to liberation'.[45]

This oppression of women is identified at all levels of society, religion and culture. Specifically, with respect to Christianity, the issue for feminists is that 'every stage of biblical interpretation in the West has been characterised by patriarchal power structures and patriarchal texts, from translation, to reading, to preaching and praxis within conventional structures'.[46] In other words, the Bible comes out of a patriarchal culture, was written by and has been interpreted by men from within patriarchal ecclesiastical and academic structures and therefore has 'tended systematically to silence women and to lend ideological support to their oppression'.[47]

This chapter will examine some of the approaches to scripture that have arisen out of this patriarchal culture and will seek to reinterpret them in the light of the freedom that comes through the cross.

[45] Linda Woodhead, 'Spiritualising the Sacred: Critique of Feminist Theology', in *Modern Theology* 13, 2nd April 1997, pp.191-212 [p.198]

[46] B. Glifillan Upton, 'Feminist theology as biblical hermeneutics', in *The Cambridge Companion to Feminist Theology*, ed. by S. Frank Parsons, (Cambridge University Press, 2002), pp.97-113 [p.99]

[47] Rachel Muers, 'Feminism, Gender, and Theology' in *The Modern Theologians: An introduction to Christian Theology since 1918*, Eds., David F. Ford with Rachel Muers (Oxford: Blackwell Publishing Ltd., 2005), pp.431 – 450 [p.431]

Arguments on this subject have raged in the church for at least the last century. While there are some who dogmatically charge any who differ in view to be in error, claiming an undermining of the authority of scripture,[48] it is generally accepted that there exists within the bounds of orthodoxy, a credible case for each,[49] and that it is untenable to consider those who would promote women in church leadership as liberals.[50]

Each side, however, remains firm in their belief and holds that the other's views stem either from unconscious assumptions long held, or an escalating doctrinal error. We must decide then, whether there are differing roles for men and women defined in scripture or whether the views we hold stem from a traditional cultural ideal.

There is certainly truth in the suggestion that we have minimised the distinctions between man and woman within today's culture, however, it is claimed that such a lack of distinction, that is rooted in creation rather than convention, has led to increased divorce, homosexuality, sexual abuse, promiscuity, and suicide.[51] It is hard to gauge though whether such a view has any merit.

We will commence our study here by considering a Biblical perspective on the nature of men and women as a function of being made in the image of God.

[48] Grudem, *Evangelical Feminism: A New Path to Liberalism?* (Crossway Books: Illinois, 2006) Kindle Ed., loc 257

[49] Belleville L. L, Blomberg C, Keener C. S, Schreiner T. R, *Two Views on Women in Ministry,* (Zondervan: Michigan, 2009), kindle ed., loc 187

[50] Forster F & R, *Women and the Kingdom,* (PUSH publishing: 2014), kindle ed., loc 67

[51] Piper J, 'What's the difference', http://cdn.desiringgod.org/website_uploads/documents/books/whats-the-difference.pdf?1414777989>, p.17

Made in God's image: The nature of God[52]

To understand the basis for the ideas we hold about the relationship between man and woman, and our corresponding relationship to God, we need to go back to the very beginning to find out who exactly is this God whose image we bear, and what form does this image bearing take.

Inherent in our beliefs, and thus reflected in the terminology of the church throughout history, is the assumption that God is male. Male theistic terminology encompasses much of scripture; we call God our Father, refer to each member of the triune Godhead as 'He', and consider as heresy anything which challenges these assumptions, however, the gender identifications contained therein are far from exclusive.

There are no gender-neutral words for God in scripture, with *Yahweh, Elohim, Adonai, Theos,* and *Kurios* all being grammatically masculine. Thus, we have traditionally used masculine pronouns when referring to God. Hebrew, Aramaic, and Greek use masculine forms to indicate generic and not genetic identity. In scripture, God the Father is never spoken of with a feminine word or pronoun, yet in both Hebrew and Aramaic the word for Spirit, with reference to the Holy Spirit, is female, and Jesus Himself, though born a man, is not the seed of man, but of woman.

Known as the *logos* and the *Sophia* of God: the Word and the wisdom, Jesus is the creative force of God - the womb through which all creation is birthed.[53] Feminine imagery is thus intertwined throughout and should not be belittled or ignored. God is Father, and Mother (Is. 42:14; 46:3-4; 66:13; 49:14-15, Hos. 11:3, Deut. 32:18; Isa. 45:9-12); King and housewife (Lk 13:20-21; 15:8-10); master and mistress (Ps.

[52] I must acknowledge the work of one of my students, Katy Bartle, in compiling much of the material in this chapter and certain other sections in this book. It is used here with permission.

[53] Rosemary Radford Ruether, *Sexism and God-talk*, 3rd edition (SCM press: London, 2002)

123:2); Daddy and Midwife (Ps. 22:9-10; 71:6; Isa. 66:9). God is the provider of food, water and clothing, all traditionally seen as woman's work[54], and all these are metaphors for finite beings to explain the infinite One who is beyond all our understanding.

Scripture tells us that God is Spirit (Jn. 4:24), and as such is invisible and unseen (1 Tim. 1:17; Heb. 11:27; Jn. 1:18; Jn. 6:47). When Moses asks His name at the burning bush, He merely calls Himself I Am (Ex. 3:14).[55] God is not physical and does not want to be pictured in a physical way (Deut. 4:15-16). He considers this to be idolatry (Ex. 20:4), and we receive stark warnings about such ideas. How is it then that we fail to recognise our own assumptions about God as such? We have attached far more significance to the gender of God as Father than is proper.

Neither male nor female sexuality is to be attributed to God, in that sexuality is an attribute of the created order. There is no reason to suspect that such polarity exists within the creator God.

Indeed, the Old Testament avoids attributing a specific sexuality to God as this would align him with a pagan understanding of male and female deities and with the fertility cults of the ancient Near East. God is neither male nor female. To use either category to describe God is to project a human understanding of the world onto the divine.

When God created humanity, it was mankind that he created, unified man and woman, and that which marriage is created to represent. To whatever degree humanity is made in the image of God, gender is irrelevant (Gen.1:27).

[54] Evans M, *Woman in the Bible*, second edition, (paternoster press: Cumbria, 1998), p. 22

[55] Ruether, Sexism, p. 57

Made in God's image: The nature of woman

'Do you know that you are an Eve? God's verdict on the female sex holds good and the sex's guilt must hold too. You are the devil's gateway, the avenue to the forbidden tree. You are the first deserter from the law divine. It was you who persuaded him (Adam) whom the devil himself had not the strength to assail. So lightly did you esteem Gods image. For your deceit... the very son of God had to die'. Tertullian[56]

Tertullian, with many other early church Fathers, held strong views with regard to women. They, along with Talmudic teaching, were somewhat influenced by Jewish writings of the time such as the wisdom of Ben Sira, which stated 'from women a beginning of sin: and because of her all die.'[57] Unfortunately, when theologians hold influence in their time, their views are often accepted as truth with little thought of refinement, and this has resulted in a history of negative attitudes towards women.[58] There has developed a picture of the husband dominating his wife, representing God Himself with us His people. Wives are to live in submissive subservience while the husband rules and sits in judgement.

God uses illustrations and metaphor as a way of helping us understand the fullness of the relationships we have with Him and in Him, however, to elevate such relationships as representative of God's relationship with His church, with imperfect man representing a perfectly just God who commands and is ruler and sovereign, is akin to making a graven image, putting man in the place of God.

[56] Tertullian, cited in Forster, *Women*, loc 140

[57] Segal E, *who Has not made me a woman*, <http://www.myjewishlearning.com/article/who-has-not-made-me-a-woman/ >

[58] Forster, *Women*, loc 140

Proponents of a complementarian view point to primogeniture[59] (the fact that Man was created first which gives him priority in terms of male and female relationships) observed throughout scripture, and claim it to be found in the narrative of Genesis 2, supported by Paul in his letter to Timothy (1 Tim. 2:13).[60] 'Patriarchal cultures have subsumed the female under a male norm – to be human is male: to be female is a derivative.'[61] However it should be noted that the woman, although formed second, was already an unformed part of man, who incorporated all that is male and female.

When a female is born she already has within her the makings of any child she could ever have - they are already a part of her. Not so with man; what is needed for his part in reproducing is made fresh, however, in this instance, the man, like woman, had within him the unformed woman. She was not, therefore, a second creation, but already part of humanity that God had created.

Although there is a theme of double inheritance with additional authority and responsibility for the firstborn that runs through scripture, this inheritance was transferable. Esau sold his birthright (Gen. 25:33), Hosah transferred the birthright and made another firstborn (1 Chron. 26:10), Jesus is called the second Adam yet receives the inheritance of the firstborn. Order of birth or creation is, therefore, not always synonymous with primogeniture.

It is also argued that the naming of woman is an exercise of authority over her, however, this is not normally a practice associated with authority.[62] Naming was a memorialising of something and was performed by both men and women.[63]

[59] Grudem, *Evangelical*, loc 533

[60] Ibid., loc 536

[61] B. Glifillan Upton, 'Feminist theology as biblical hermeneutics', in *The Cambridge Companion to Feminist Theology*, ed. by S. Frank Parsons, (Cambridge University Press, 2002), pp.97-113 [p103]

[62] Belleville, *Two Views*, loc 333

[63] Evans, *Woman*, p. 16

While Adam did indeed identify the title, 'woman' it was a word that showed her as his equal, not his subordinate.

'This is now bone of my bones
And flesh of my flesh;
She shall be called Woman,
Because she was taken out of Man.' (Gen. 2:23)

The Hebrew is quite distinct in this. Adam specifically names the animals but recognises woman for what she is. The Hebrew phrase translated 'she shall be called woman' can be rendered literally as 'of this one it will be said "woman"'. Thus, Adam is not naming her but identifying that which she already is.

There was no hierarchy before the Fall but both man and woman were commissioned with the task of stewarding the earth (Genesis 1:28). The purpose of separating male from female was to create a suitable companion for each of them because 'it is not good for man (or woman) to be alone' (Genesis 2:18).

Again, after the fall, Adam names her Eve, as she would be the mother of all living (Gen. 3:20), and yet, given that reproduction had been ordained before the fall, it may be strange that he had not already named her. In Genesis we are told that there would now be enmity between the woman and Satan, and between her seed and his (Gen 3.15). Where man had blamed God, woman had exposed Satan (Gen. 3:12-13).[64]

Being a woman, Eve did not have a seed, however, there would be one seed that would come from Eve alone, and not from man. Because of man's sin it was not possible to bring anything other than a sinful nature through the man (see Augustine on Original Sin), however, through Eve alone, by

[64] Forster, *Women*, loc 168

the Holy Spirit, would come the One who would 'crush your head...' (Gen. 3:15).[65]

As 'helper' (*ezer*), woman has been seen to be somehow less than man, with many traditionalists believing this to mean subordination.[66] However, elsewhere this term is used as a picture of coming to the aid of someone as one of strength, many instances making reference to the help of God alone (Ex. 18:4; Deut. 33:7, 26, 29; Ps. 20:2; 33:20; 70:5; 115:9-11; 121:1-2; 124:8; 146:5; Hos. 13:9), and as such rather than a subordinate servant or slave, woman becomes the needed partner of man, equal in every way. Their marriage then was to be a 'functional oneness not hierarchical twoness'.[67]

There is no hint of subordination in the creation story. Genesis tells us, 'But for Adam there was not found a helper comparable to him' (Gen. 2:20); there was not found a helper as his counterpart, his equal. We read also that both received the same blessing, both received the same commission (Gen. 1:28). This is the divine mandate that has been restored through the cross. Together we are to rule the earth on behalf of, and bring it into subjection to the will of, the Creator.

Both male and female were called to obedience, and both are held accountable before God for their own actions. In Acts, we read about Ananias and Sapphira, both of whom were called to account for their lying over the deception of Ananias. Both were equally accountable for their own sin, even though Sapphira merely backed up her husband (Acts 5: 1-11). In the garden of Eden, Man was held to account for his disobedience and his blaming of God and thus it would be through his seed that the curse of sin would be passed

[65] For a discussion on Augustine's concept of original sin see Alistair McGrath *Christian Theology: An Introduction*

(Oxford: Blackwell 2007), p. 362

[66] Grudem, *Feminism*, loc 586

[67] Belleville, *Two Views*, loc 331

(Rom. 5:12), whereas, for the woman, whilst also being called to account for her actions when she was deceived, her exposure of Satan led to her being the one through whom the redeemer would come (Gen. 3:15).

Eve indeed was punished for her part (Gen. 3:16), however, what followed was an explanation of how things would be: 'yet your desire will be for your husband, and he will rule over you' (Gen. 3:16). This serves to explain the dysfunction that had occurred in their relationship, not a command of how things should be. The same theme of desire and rule is used in reference to Cain and sin (Gen. 4:7), and again shows that this kind of domination and not headship is a distortion of what God had made.[68]

When Adam blamed God for the woman He had given, Adam had developed a disdain for His wife. Their relationship was no longer the perfect equality it once had been, however, this was not prescriptive from God, but rather a direct consequence of Adam's disobedience and Eve's weakness - a weakness which Adam recognised - and so began the dysfunctional gender hierarchy that remains rife today.[69] Satan was warring against her fruitfulness and authority (Gen. 1.27), until Christ would come to bring in His kingdom and undo the consequences of the fall.[70] As Rachel Hickson points out, Religious spirits (whether they are through Islam, Hinduism, Judaism or the church) particularly target women and the result of this oppressive atmosphere is misogyny, patriarchy and the suppression of women.[71]

Rosemary Radford Reuther, recognises in her promotion of the full humanity of woman that such an attitude has

[68] Ibid., loc 2475

[69] Ibid., loc 2475

[70] Forster, *Women*, loc 256

[71] Rachel Hickson, *Release My Frozen Assets: A look at the role of women in the church* (Oxford: Heartcry Ministries, 2013), p. 81

continued from Adam throughout the generations. It is one that has woman scapegoated for sin and marginalised.[72] Many complementarians today fail to see the dysfunction in such unequal relationships. They fail to recognise that, where the Old Covenant accommodated this dysfunction with the circumcision of male alone as the sign of the covenant relationship, we now have baptism for all, both unto death through the water, and into life through the Spirit. This demonstrates a new equality in the coming kingdom which begins in the here and now.

Conclusion

Because God is outside of gender, the image we are made in can have nothing to do with gender. Thus, the totality of man and woman is not needed to express the image of God, rather both are expressions of the image of God, individually complete. These separate images have a greater completeness when they work together. This image is now damaged, hence, now, when we become children of God, we begin to be transformed into His image (2 Cor. 3:18; Rom. 8:29). That is both at an individual and a corporate level – the church should reflect the values of the new kingdom, not the fallen world.

[72] Ruether, *Sexism*, p. 31

Chapter 4

The 'Difficult Passages' – submission and authority

Within the New Testament we have a number of references to the way women should act and the way men should act. Most of these are in the writings of Paul who has been identified by many feminist writers as a misogynist. I believe this reading of Paul is unfair since it fails to take into account the culture in which he was writing and his passion to see the church effective in transforming society through the gospel, without creating any unnecessary offence that would be a hindrance to the gospel.

In the remainder of this chapter, we will consider the 'difficult' passages that have formed the belief and practice of the church concerning women, and will seek to interpret them, both as Paul intended them to be understood, and as they can be applied in our 21st Century ecclesial life.

Male Headship & Gender Difference

The first issue that needs to be considered here is that of male headship – whether it is a spiritual principle, or whether it springs from the cultural norms of New Testament times, or from a patriarchal interpretation of scripture.

The issue of male headship is one that is prevalent in the New Churches and particularly with respect to the question of the leadership role of women in the church. The dilemma

appears to be a desire on the part of male leadership to liberate women to become all that they can be in the church, on an equal footing with men, whilst not forsaking a principle deemed to be 'spiritual' rather than 'cultural' – the principle of male headship as found in (or at least interpreted from) the writings of Paul. But is this interpretation rooted in androcentrism rather than it being a spiritual principle?

The essential New Testament passages that are used to affirm the position of male headship are 1 Corinthians 11:3-16, 1 Corinthians 14:34-36, Ephesians 5:22-33, 1 Timothy 2:8-15. Elizabeth Schussler Fiorenza suggests that in 1 Corinthians 11:2, Paul presents us with a 'peculiar theological patriarchal chain: God-Christ-man-woman', but she affirms that Paul's arguments in this section of 1 Corinthians are 'convoluted' leaving us uncertain as to exactly what Paul is advocating here for 'women prophets and liturgists'.[73] Keener gives a very convincing argument as to why these passages do not affirm male headship and rather present a picture of liberation for women in the New Testament church.[74] Let us consider these key passages.

1 Corinthians 11:2-16

The word translated 'head' in 1 Cor. 11:3 also means 'source'. It would seem that Paul is affirming the creation order, as is stated explicitly in 1 Cor. 11:8. Thus, in wearing a head covering, according to Paul, a woman honours the creation order. It is source as opposed to authority that is

[73] Elizabeth Schussler Fiorenza, 'Rhetorical Situation and Historical Reconstruction in 1 Corinthians' in *Christianity at Corinth: The Quest for the Pauline Church*, eds. David G. Horrell and Edward Adams (Louisville: WJKP, 2004) pp.146-160 [p.155]

[74] C.S. Keener, 'Man and Woman', in *Dictionary of Paul and His Letters: A Compendium of Contemporary Biblical Scholarship*, eds. Gerald F. Hawthorne, Ralph P. Martin, Daniel G. Reid (Downers Grove: InterVarsity Press, 1993), pp.583-592

being referred to here. There is no sense in the Greek that the word translated into English as 'head' (*kephale*) inferred 'authority' despite what some (such as Grudem) have tried to prove otherwise.

Throughout, Paul is using a play on words as he gives a double meaning to 'head'. Within the culture of the time, a woman with an uncovered head was one who was looking to attract a man. Thus, Paul is upholding that, in covering her head, a woman was affirming her marital status within the society and, thereby, honouring her husband. The equivalent expectation in our culture would be for a married woman to wear a wedding ring.

In addition, within the Corinthian church, there were women of both high and low status, and both Greek and Hebrew women. The convention amongst the Hebrew married women was to have their head covered, however, fashionable Greek women, whether married or not, would have their head uncovered and would wear elaborate hairstyles. We know from later on in the chapter that the wealth and status differential within the church was causing disunity, particularly at the Lord's Supper. Paul's instruction is, therefore, also practical: to minimise the display of this wealth differential and bring about a greater unity within the church.

Further, the instruction of Paul for women who would not cover their head to shave their head is hyperbolic. In the culture of the day, prostitutes would often shave their heads and so, effectively, he is saying, if they will not honour their husband, they might as well appear to the world as prostitutes.

In v.11., he reaffirms the total interdependence of men and women, and then reaffirms that a woman's hair is 'her glory' i.e. the ultimate display of her beauty and femininity.

However, in the church, it is the glory of God that should be displayed.

In our culture, hair is a cultural non-issue, however, we can still see such attitudes regarding hair being a woman's glory and beauty in the Muslim practice of wearing a bourka. The idea is that the beauty of the woman is reserved for her husband only. As Westerners, we tend to be appalled by the restrictiveness and androcentricity of this practice. However, for the New Testament culture, particularly amongst Jews, such a notion was normal.

Thus, since this whole instruction is given by Paul in order to suggest an appropriate way of men and women to behave within the church and in honouring one another based on the culture of the day, it is not appropriate to derive the notion of male headship from this passage. Instead, the principle here is mutual honour between husbands and wives. It was culturally informed within the Corinthian church and therefore must be interpreted appropriately in our own culture. Suffice to say, based on this passage alone, Paul is not affirming a universal principle of male headship, but is rather dealing with a divisive issue in the Corinthian congregation in a practical manner (just as he does elsewhere in Corinthians).

1 Corinthians 14.34-35

Paul wrote this letter to the church at Corinth following reports of erroneous teaching and various divisions that were arising among them (Acts 19:1; 1 Cor. 1:11).

In the passage in question, Paul is giving instructions on Christian order. He has already taught on the use of spiritual gifts, and on what the attitude of the church ought to be towards prophecy and has moved on to instructions for the

church services and how they ought to be structured. The only religious experience these people had known prior to the birth of the Corinthian church was within the Jewish synagogues or pagan temples.

Women were allowed to observe what happened in a synagogue but were not allowed to participate.[75] Rabbis despised women who desired to teach: 'let words of the law be burned rather than committed to a woman'.[76] As a result the women in the emerging church, especially the married women who were generally less well educated, were becoming disruptive. Once able to chatter freely amongst themselves within their separate enclosure, such chatter was now disruptive within the main service. They asked uneducated questions based upon their limited knowledge, and all this was taking place in response to the questionable teaching that was flowing into the church and in the context of the already disordered services.[77] Into this chaos arrives Paul's letter, hoping to instil some order and decorum.

Paul instructs the married women (for the unmarried had no husbands to ask) to ask their husbands at home anything they did not understand. This was purely because the questions the women were asking were a distraction from the teaching that was taking place. The word Paul uses for 'silent' in this verse he uses 3 times in 1 Corinthians 14: in v.28 to limit tongues; in v.30 to limit prophecy; and here it is used to limit women speaking in church.[78]

That he does not mean to prohibit women from speaking entirely is clear from other scriptures where women prayed and prophesied publicly (1 Cor. 11:4-5; Acts 1:14; 2:4). The

[75] Author unknown, *Women in ancient Israel, Jewish Women and the temple*, <http://www.bible-history.com/court-of-women/women.html>

[76] Forster, *Women*, loc 1309

[77] Forster, *Women*, loc 1302

[78] Forster, *Women*, loc 1282

same word for speak here, *laleo*, is used elsewhere to denote singing (Eph. 5:19) which we know was permitted for women to do (2 Chron. 35:25).[79] One common interpretation that Grudem thinks fits best is that women should keep quiet during the judging of prophesies (1 Cor. 14:29), as this also restricts the governing authority of women over men, however, although this fits well with his views on the restriction of women, there are no supporting scriptures that place limitations on the judgement of prophecy by women and hence such conclusions must be drawn with caution.[80]

To use this practical instruction regarding church order to restrict women from teaching or preaching is an extrapolation too far and is not supported by the text.

Ephesians 5:22-33 & Colossians 3:18-19

The household codes of Ephesians 5:21-6:8 and Colossians 3:18-4:1 are mirrored in the writings of others. These are not the only household codes in ancient literature. Others, such as Aristotle, similarly wrote household codes with respect to wives, children and slaves. However, the content of the other household codes was directed entirely at the male householder and instructed him how to govern his household. In contrast, Paul lays out responsibilities for all involved. Indeed, he begins this whole section by telling everyone concerned that there needs to be mutual submission to one another (5:21), out of reverence for Christ. He concludes these instructions by telling everyone that, ultimately, we are all in submission to Jesus and therefore need to behave as if that is the case (6:9).

[79] Forster, *Women*, loc 1289

[80] Grudem, *Feminism*, loc 792

As we read these passages, a number of the perspectives espoused by them seem to clash with our modern mindset. Some have suggested that Paul is endorsing the suppression of women and condoning slavery, however, to approach these passages with this mindset is anachronistic and is to take them completely out of the cultural context in which they were written which leads to misunderstanding.

In order to interpret this passage properly, we need to understand the cultural norms of the day. Essentially, within Greek society, it was customary for men not to marry until they were in their thirties. Prior to then, sexual encounters for men were with slaves, prostitutes or with one another. Thus, when they did get married, it was often to a woman much younger and less intellectually mature. Such marriages were often through familial arrangement in order to form alliances. In addition, these marriages were primarily for progeny and not for companionship or love.

What Paul is advocating in Ephesians 5:22-33 is actually really radical. He asks wives to respect their husbands and to honour them, thus reinforcing the role of the husband within the society of the day. The purpose of this instruction was to reduce any outrage from unbelievers observing Christian marriages. However, the really radical part is that he instructs husbands actually to love their wives and that sacrificially! They were not just to treat them as chattels or as a source for begetting children but were to lay down their lives for them in order that the woman might be able to pursue her life in Christ more fully.

Paul is not supporting a universal principle of headship here, but rather is addressing a cultural issue in order that married Christians could be an example to society and could exemplify a different way of living that honoured gender difference, whilst enabling both parties to become all they were meant to be in Christ.

There is a wider issue, of course, identified by Elizabeth Johnson: 'The Church reflects this inequality, in its sacred texts, its religious symbols (most importantly, God), its rituals, governance, and laws'[81]. For the New Churches, some of these items are less relevant (rituals, governance and law are all flexible and able to be changed rapidly in response to circumstances since they are not canonised). However, I would suggest that an inclusive theology is the first step towards creating an inclusive church environment, free from androcentric patriarchalism. This requires a change of church culture since the patriarchal culture has a fundamental role in 'maintaining oppressive social relations'.[82] Removing the theological barrier regarding male headship is the first step in this process towards opening the door to a full and equal role for women in the New Church communities.

1 Tim 2.9-15

Attributed to Paul, this letter was written almost 10 years later than the letter to the Corinthian church. Rather than being addressed to a church as a whole, this letter is written to his protégé and fellow worker and church leader Timothy (1 Tim. 1:2). It is written to assist Timothy in his dealings with false teachings that were entering the church and is a set of instructions concerning how to go about getting things back on track (1 Tim. 1:3-5).

First of all, Paul calls for unity among the men. He specifically uses the word men, not because he didn't want

[81] Elizabeth A. Johnson, 'Women's Place: Two conflicting views guide the church's position on women and have from the very beginning and therein lies hope', *Boston College Magazine* Summer 2004

http://bcm.bc.edu/issues/summer_2004/features.html [accessed: 27/03/2012]

[82] P. Abbot, C. Wallace & M. Tyler, *An introduction to sociology: feminist perspectives* (3rd Edition), (London: Routledge, 2005), chapter 2: 'Feminist sociological theory', pp.16-56 [p.44]

unity amongst women, but because he was addressing a particular issue of which both the author, and the recipient were aware. There needed to be no explanation or elaboration on such points that were clear to both. He first outlines the appropriate way for the men to behave during prayer, and then follows with the appropriate way for the women to behave.

Paul then goes on to speak concerning the proper conduct of women when among the church. He uses phrases like 'I want' and 'I do not allow,' because this is advice from the wisdom of Paul - advice for specific situations that were raised within a specific culture.[83] Paul himself understood his own limitations in mind and will (1 Cor. 7:6-7, 25; Gal. 5:12).[84]

That he is speaking within a cultural context is clear because only ten years earlier Paul instructed women to wear a head covering (1 Cor. 11 5-10, 16), whereas he now speaks merely of not braiding the hair. Paul's main focus is not what the woman shouldn't wear, but on what the women in the churches ought to be doing, what they should adorn themselves with rather than what they shouldn't.

As we said previously, at this time wealthy single women adorned themselves with rich clothes and fancy hairstyles in the hope of attracting and seducing men, and of demonstrating their wealth.[85] However, the only glory that ought to be seen in church is the glory of God and His son Jesus Christ. Anything that was proving a distraction to that was to be discouraged. To men, he calls for an end to their anger and disagreements and instructs them instead to come together in prayer. Likewise, the women are to stop

[83] Forster, *Women,* loc 928

[84] Forster, *Women,* loc 930

[85] Forster, *Women,* loc 1026

concentrating on how they look, and instead consider how they behave, in order to demonstrate their true beauty.

Paul goes on to instruct that a woman should learn quietly and in submission (1 Tim. 2:11). What ought to be key here is that women were encouraged to learn, however, people from a complementarian view emphasise that they were to do so quietly and in submission, interpreting this to be unquestioning silence. We are all called to be in submission to those who teach and instruct in the word of God. This also relates to the Corinthian situation where the uneducated women were being disruptive by asking too many questions. The word used here (*hesychios*) does not indicate silence but rather to quieten down and to cease objecting so as to listen, just as it is used in Acts 11:18 and acts 21:14. It is similar to the command to men in v.8 who are instructed to learn 'without anger or disputing'. In other words, it is part of the wider instruction to end disruptions in worship.

Paul then goes on to begin to address another problem that had arisen. False teachers were gaining access to the minds of uneducated women and filling them with false doctrine, which was then permeating the church (2 Tim. 3: 6-7). It is implied that women were teaching this doctrine, and, as it was not in line with scripture, were seizing the authority over that teaching, speaking it as truth.[86] As a result of this issue, and of concerns that a woman seizing authority over a man could have damaged the church's witness in a tense social situation, Paul placed a limitation on women teaching in this specific church. He was warning against the taking of authority away from those to whom it ought to belong. He then goes on to emphasise the ease with which woman had been deceived in Eden and had thus fallen into error due to her lack of sound teaching. Paul was not claiming that only women can be deceived, for he knew everyone could (2 Cor.

[86] Keener, *Paul*, p. 590

11:3). Rather, he was merely using this as an example to demonstrate his point about the ease with which uneducated women can be deceived. This was a short-term solution following the previously mentioned long term solution: that they should learn.[87] We ought not to attribute more meaning to this passage than is written, especially in the light of the tense cultural situation in which Paul and Timothy lived. To build an entire doctrine on the back of this scripture alone would be unwise.

For a fuller explanation of these verses see C.S. Keener 'Man and Woman' in *Dictionary of Paul and His Letters* pp. 583-592

Conclusion

The New Testament identifies divisions of class, ethnicity, and gender as having been overcome by Christ. Beginning in the genealogies, Jesus is shown to be Messiah to the marginalised.[88] However, much of the egalitarian nature of the ministry of Jesus has failed to continue into the establishment of the church following those early years, other than when challenged and provoked by the example of radical church movements such as the Anabaptists, Quakers, John Wesley, and William and Catherine Booth, all of whom championed rights and equalities of women.[89] Despite this, the church has continued to lean towards the finding of pharisaic style rules with which to live by rather than living in the freedom Christ gives us.

Jesus freed us from the earthly bounds of unequal relationships and showed us how we ought to live as family members in one church. He wills us to live in submission to

[87] Ibid

[88] Blomberg, *Two View*, loc 2623

[89] Forster, *Women*, loc 118

the authority that surrounds us, whether that be political authority, or church leadership, and to be in respectful submission to fellow workers. Even when we live within those unequal relationships, be they gender inequality, or slavery, we are shown how to live freely within them. This does not mean that Christ advocated such unequal relations.

Both Jesus and Paul lived within and understood their cultural norms. From this standpoint they were well positioned to challenge those norms that were not in line with the gospel of Christ. The culture we live in today is very different from the one into which both Jesus and Paul were born, and we must adapt to current cultural norms accordingly, not in order to dilute the word of God, but in the realisation that some instructions were relevant for a particular situation and time. So as not to damage the witness of the gospel, we are to remain culturally relevant, and in so doing are then in a position to challenge culture, so to further the message of the gospel of Jesus Christ.

That there should be a class of people condemned to perpetual poverty; that there should be people who have no choice but to be slaves; that there should be whole races loved into inferiority of status; and that half of humankind should be made subservient to the other half on the grounds of gender – all these inequalities have been dealt a death blow by the gospel, which shows the way of redemption, freedom and blessing for all classes and conditions of men and women.[90]

So what role can women perform in the church? Any that they are gifted for!

[90] Forster, *Women*, loc 510

Chapter 5

Women in Scripture – Old Testament

Introduction

In this chapter, we will examine some of the women of the Old Testament and how God used them regardless of their gender (or perhaps because of their gender), irrespective of the culture of the time. Whilst they appear very much in a patriarchal context, they cross the boundaries and limitations of culture in order to see the purposes of God worked out through them. In doing this, they are often portrayed as on an equal footing with men within the narrative.

At first glance, the Old Testament appears to be steeped in sexism and gender inequality – certainly this is how many feminist theologians view it, and possibly with good reason considering the interpretation given to such writings over the last couple of millennia. However, when we understand more fully the stories included such as that of Eve (see Chapter 3 above), a less patriarchal picture of the Old Testament begins to emerge.[91] Despite the culture of the times, God never shied away from using women, as well as men, to fulfil His perfect will and purpose, and to honour them.

Sarah & Rebecca

So, what do we know about Sarah? Firstly, her name means 'Princess'. The word 'Sar' in Hebrew meant 'captain' or

[91] Forster, Women, loc 275

'commander' and so Princess is not just a notional title but is also indicative of one who carries authority. As such, she had a key matriarchal role over the House of Israel. It is also indicative of the fact that kings would come from her offspring.

The name Sarai, with which she begins the journey, can mean 'contentious'. However, after she receives the promise that a son will be born to her within a year, in Genesis 17:15, she is given the name 'Princess', to go with the promise. The promise of God shapes her identity and destiny. Abraham was even instructed by God to listen in obedience to her (Genesis 21:12), using the same word '*Shama*' as is used for the obedience which Abraham showed unto God Himself when called upon to sacrifice His son Isaac.

When Abraham later sends his servant to find a wife for his son Isaac, it appears that Isaac, the male, is the only one not consulted in the arrangement (Gen. 24:4-8). While Rebecca is approached in hope, it is only through her wilful acceptance that she becomes the wife of Isaac, travelling against the convention of her time, away from her family home (Gen 24:28) to be joined to Isaac in marriage (Gen. 24:5; 24:56). She is shown to be the model of Middle-Eastern womanhood in the first part of the narrative.

In the second part, however, we see her ensuring that the prophecy over her sons is fulfilled, despite Isaac's blindness (his physical blindness is a picture of his spiritual blindness as we see him obsessed with the older son, Esau, to the extent that he ignores the purposes of God which have been spoken over the younger son). It is left to Rebecca to ensure that what has been spoken over Jacob is enacted (Genesis 25:23).

Rachel & Leah (Bilhah & Zilpah)

In the narrative of Jacob and his wives (Genesis 29:1-35; 30:1-24; 31:19-21, 31-35; 35:16-20), we encounter a situation very far removed from our Western norms. We see bigamy, sexual exploitation of female servants, favouritism, and a form of prostitution as Leah buys a night with Jacob with her son's mandrakes (Genesis 30:16). None of this is very palatable for a modern readership, flowing as it does out of a very patriarchal society, and yet it portrays much in the attitudes and behaviours of humanity that are still resonant.

Despite all of these issues, we see four women who, between them, establish the twelve tribes of the nation of Israel and bring about God's purposes for successive generations. These women operate within the culture of their day but are not subsumed as simply passive females within the narrative.

Leah is used as a pawn by Laban who wants to marry off his 'ugly' daughter and tricks Jacob into marrying her. Despite this, God blesses Leah such that she becomes the most fruitful and the most honourable of the women in this narrative. It is from her that both the priestly tribe (Levi) and the royal tribe (Judah) come and so, despite her abuse by Laban, Jacob and Rachel in the narrative, she is exalted amongst the patriarchal family.

Rachel, on the other hand, is not so well portrayed in the narrative. Despite being the object of Jacob's desire, she is jealous and manipulative of her sister (Genesis 20:1-15), and it is she that initiates Jacob sleeping with the servant girls. She is perhaps a model of female compliance with patriarchy.

The servant girls, Bilhah and Zilpah, play little part in the narrative except as the pawns of Leah and Rachel and the mothers of more of Jacob's children. Within the culture, such

servant girls had no rights and are therefore treated totally as objects. It is not scripture that is responsible for this as the Bible tends to present people as they are rather than how we wish them to be. Instead, it is the culture of the day that is responsible. However, as the purposes of God unfold throughout scripture, we see a development of the notion of marriage between one man and one woman as the ideal.

Miriam

Miriam was known as a prophet (Ex. 15:20-21) and was a fellow leader of the people of Israel with Aaron and Moses.[92] When she fell into transgression, she was disciplined as any true son of God would be (Heb. 12:6), for to whom much is given, much is required, whether man or woman.[93]

In this early part of the Exodus narrative, we see Miriam acting as the guardian of the baby Moses as his mother sets him afloat on the Nile river, hoping that somehow, he will be preserved. God had a plan for this young baby that went beyond just saving his life. He was to grow up in a palace as a prince in order, one day, to become the deliverer of Egypt. Miriam was present on the scene to observe and to safeguard this young baby. Her cleverness enables his own mother to be able to nurse him and bring him up as a toddler. Perhaps, when he was growing up, they were able to ensure that he knew his roots as, later on, we see him defending a Hebrew slave from an Egyptian slave master. Certainly, he knows where he has come from and, I am sure, Miriam had a part to play in that.

What became of Miriam in the years following this incident until the Exodus we do not know. There is no mention of a

[92] Forster, *Women*, loc 326

[93] Forster, *Women*, loc 330

husband or children. According to Josephus, she married Hur and became the grandmother of Bezalel, the maker of the Tabernacle, but we have no Biblical corroboration of this. We do know that she is named as a prophet in Exodus 15:20. Presumably, that did not just happen on the bank of the Red Sea after the miraculous escape of the People of Israel, but that she had long been exercising the ministry of a prophet amongst the Hebrew slaves.

Miriam was also well respected such that, in the incident when she contracts leprosy, the people of Israel will not move on until she is restored amongst them (Numbers 12:15).

The one negative incident of the life of Miriam is her rebellion against Moses in Numbers 12. The issue in this case is not that she is a 'rebellious woman,' but that she failed to discern the seniority of Moses in the leadership of the people of Israel. Why Aaron got away with his rebellion in this same incident we do not know. However, whether male or female, we need to respect those God places amongst us who carry senior authority. There was no doubt of Miriam's leadership amongst the people. It was simply her attitude to Moses' leadership that was the problem. Perhaps this was as a result of being his big sister?

Rahab

Rahab's profession, in Hebrew is rendered 'zanah', which is a very strong word and for which the English equivalent is 'whore' and in the Greek of the Septuagint it is rendered 'porne', which means the same, and from which we get the English word 'pornography'. So, whilst some well-meaning interpreters have tried to suggest that she was no more than an innkeeper, I don't think you have to look far to work out what kind of inn she was keeping. Once again, the Bible does not try

to gloss over this detail. In fact, both the writer to the Hebrews (11:31) and James (2:25), refer to her as 'Rahab the prostitute'. There is no getting away from this aspect of her life.

However, her actions in the narrative cause her to be mentioned in the list of the heroes of the faith in Hebrews 11. What brought this about? It was her recognition of the power of God (Joshua 2:11) and the need to operate on His side, despite being an outsider. As such, she represents all Gentile believers who, although outside of the covenant purposes of God, have been brought in through faith and through the 'scarlet cord' of Christ's blood.

It is not the king of Jericho who expresses faith in God, but one who would have been considered the least in her culture. Her reward is being named in the line of the Messiah (Matthew 1:5).

Deborah

Deborah is identified as the leader of Israel (v.4). She is the fourth of the judges after Othniel, Ehud (the left-handed), and Shamgar. What is remarkable is that she is very much a woman in a man's world. She is the first woman in the Old Testament to carry such a position of authority amongst God's people (with the exception, perhaps, of Miriam), and yet the scripture is clear on this point. She 'held court at the Palm of Deborah between Ramah and Bethel in the hill country of Ephraim, and the Israelites went up to her to have their disputes decided' (v.5).

What her background was, who her family were or how she rose to that position are all unknown. We do know she was married to Lappidoth (Judges 4:4), but there is no indication in the text that he shared her ministry position with her. We also know is that she was respected and honoured throughout Israel. In addition, she was vital to Barak, the

leader of the army, who would not go up to fight without her guidance and counsel.

We also know that she was a prophet. She had the ability and gifting to hear from God and to impart his word to the people. Similarly, she had the ability to write and compose songs to be sung by the people, as we see in Judges 5. Thus, she was a woman of gifting whom God raised up to lead his people. We know of very few other women in antiquity who held such a prominent position. Perhaps we could mention Artemesia of Caris who fought with Xerxes at the Battle of Salamis, or the Queen of Sheba, Hatsepshut, Nefertiti or Cleopatra of Egypt, or even Boudicca of the Iceni, but one has to look far and wide for any others.

What is clear is that her gender was no restriction on the role she was called to play within Israel over an extended period of time and her actions, and support of Barak, brought about the deliverance of Israel from oppression.

Ruth

In the narrative of Ruth, we see once more an outsider (like Rahab) joining herself to Israel and becoming part of his covenant purposes. Her actions demonstrate a sensitivity to God and absolute submission within the patriarchal system in which she found herself. Nevertheless, she was used by God to contribute to the line of kings (David's line) and ultimately to the Messiah. As such, she also is a representative of the Gentile nations being brought into God's covenant purposes.

In Ruth 3:11, Ruth is described as a woman of *Cha-yil*, or in other words a woman of strength, might, valour, power. She is chosen by Boaz because of her strength, not her meekness or subservience.[94]

[94] Forster, *Women*, loc 373

Hannah

We encounter Hannah standing before the tabernacle and praying silently to herself, moving only her lips. Her promise to the Lord was that, if he listened to her cry for a child, she would give the child back to him. I don't think we can underestimate the sacrifice she was making in this bargain with God. A child would remove all her shame within the community, and yet, in the receipt of the child, she would give him up again to the Lord.

As she is praying, Eli, who is standing at the door of the Tabernacle, observes her lips moving and no sound coming out, so he thinks she is drunk and rebukes her. However, she explains her plight to him and speaks of her grief and passion in making this request known before God. In response, Eli blesses her and joins with her prayer.

In 1 Samuel 1:20-23, we find that God answers her prayer as a result of which she does not go up to the tabernacle the following year because she is looking after the child that has been born. The year after that, however, she returns with the boy, now about 18 months old and fully weaned, and fulfils her vow, leaving him with Eli. The boy's name, of course, is Samuel which means 'God has heard'.

The result of Hannah's faithful petition and obedience to her vow was that God was able to take Samuel, and use him to bring about a spiritual revolution in the nation. Not only did he become the judge of Israel, but he also became a prophet and the anointer of kings. All this flowed out of Hannah's deep desire for a child but also her willingness to be obedient to the Lord and self-sacrificial in the outworking of that obedience. Such emotional resilience in the giving up of her son to God's greater purposes is only to be admired.

Bathsheba

Often, in commentaries, Bathsheba is portrayed as a 'scarlet woman', but I think that is grossly unfair. It is not how she comes across in the narrative of 2 Samuel.

Her name means 'the seventh daughter'. This suggests that she was one of a large family. She was the daughter of Eliam, who was the son of Ahithophel. Ahithophel was, of course, one of David's advisors who sided with Absalom when he rebelled against David. Thus, she was from the family of one of David's closest advisors.

We find David, at the beginning of this narrative, safely closeted in his palace when he should have been with his army fighting the Ammonites. The saying, 'the devil finds work for idle hands' comes into its own in this story. One night, David can't sleep and when wandering on his roof top, he sees on another rooftop a woman taking a bath. This would not necessarily have been unusual. What is unusual, however, is her beauty (v.2).

Of course, being beautiful is not a sin, and neither is taking a bath, however, looking at naked women, particularly when she is someone else's wife when you should be at work, is. This was David's problem and it is he who is responsible for what happens next.

David sees this woman and, despite the fact that he learns that she is married to Uriah, he sends for her. Some have suggested that she should at this point have resisted his advances, and perhaps she should, but when a king has summoned you, particularly in the patriarchal society in which she lived, it would have been very hard to resist him – or say no. She is a woman 'more sinned against than sinning' (King Lear Act 3, Scene 2, line 59-60).

Later in the narrative (2 Kings 2:13-22), we see Bathsheba fighting for the rights of her son. In doing so, she shows

complete reverence and respect for David. She bows before him, addresses him as 'my lord', and reminds him gently of his promises and the implications of him not acting. If ever her behaviour was inappropriate before, she is held up as a model of queenly conduct in this episode. She is not demanding of David, but respectful and dignified, and David responds appropriately to give her what he has promised.

Regardless of how we might consider this kind of honour towards the king, within the patriarchal context, Bathsheba acts appropriately, however, her passion is to see the promise of God fulfilled through her son Solomon.

Vashti

The name 'Vashti' means beautiful woman. Indeed, it is her beauty that is highlighted by the biblical author of this story. This stands in contrast with the ugliness of the episode related. However, it is her strength and determination in the face of misogyny that stands out.

To set this story in context, the Persian king, Xerxes, has spent one hundred and eighty days with his military commanders. We know from history that this was in preparation for the invasion of Greece. At the end of this period, he holds a seven-day feast in which he shows off all his wealth 'and the splendour and glory of his majesty' (Esther 1:4). Being very drunk, he turns to the one item of 'glory and majesty' that he has not yet shown off – his queen.

Within the culture of the time, a woman's beauty was for her husband alone. That is why wives of rulers were kept in palaces guarded by eunuchs. Whilst we may consider such an idea archaic and restrictive, it enables us to see why Vashti reacted as she did. To bring her out in front of his guests would have been to publicly disgrace her. It would be

the modern equivalent of a husband getting his wife to walk naked in front of his friends.

Xerxes was dishonouring his wife and queen in every way possible. He was displaying her as an object before his guests in order to demonstrate his own power and glory. Effectively, he was showing off, but at Vashti's expense. Further, he was breaching all custom in order to satisfy his own ego.

Her refusal to do his bidding is courageous indeed. I am sure she would have known that this action on her part would have had negative consequences. She would not allow herself to be objectified even though it cost her her crown and her place at court.

Prior to this episode, she had performed all her duties in full, including entertaining the wives and courtesans of the guests, giving them an equivalent seven day's banquet. She was not seeking to be a model of a disobedient wife, as the King's counsellors suggested (Esther 1:16-18). Rather, she was adhering to custom and maintaining her own dignity at huge cost to herself. In this sense, she really is an example to all women not to put up with misogynistic abuse.

Esther

Esther is a most unlikely heroine in the narrative of the Old Testament. Essentially, she is the winner of a beauty pageant who is used by God to bring salvation to her nation. She was the one who 'attained royalty for such a time as this' (Esther 4:14).

Throughout the narrative she demonstrates her obedience to the patriarchal society in which she finds herself, both to Mordecai and to Xerxes. However, she also shows herself as a woman of courage as she goes to the king unasked for at

risk of death. She shows herself resourceful in planning the banquet for the king and Haman. She shows herself patient in putting on the second banquet. She shows herself determined in asking for a second day for Israel to gain vengeance on their enemies.

Esther is not stereotyped as 'beauty without brains'. Instead she shows herself as the complete woman, using her power wisely to bring about the purposes of God for her nation.

Huldah

Huldah, was a female prophet in the reign of Josiah (2 Chron. 34:22-28). Rather than being a meek subservient wife to her husband, she was approached directly when the King sent Hilkiah the priest to enquire of the Lord, along with the King's servant and a scribe. She replied to them with boldness and authority, giving the word that God had given her.[95]

Conclusion

Whilst all of these women act within the constraints of the patriarchal society in which they found themselves, many of them, such as Deborah, break the mould of expectation that sought to contain them. Others, such as Esther, showed bravery and fortitude even when society and the law itself were against them. Each one of them rises out of the Old Testament narrative as women of determination who overcome, often against the odds, in order to influence the destiny of the nation.

We will deal separately with Jezebel in the next chapter.

[95] Forster, *Women*, loc 365

Chapter 6

Women in Scripture - Jezebel

Introduction

Jezebel is the ultimate Femme Fatale, or at least that is how she has been presented over the centuries. When Bette Davis starred in the film *Jezebel* in the 1930s which concerned a woman who seduced a man and led him to his death, it reinforced all of the stereotypes that exist in our minds concerning Jezebel.

The tag-line to the film was, 'She was half siren-half angel-all woman! Many men loved her and died for her but the only man she ever loved called her "the wickedest woman who ever lived"!'[96]

Thus, the name Jezebel has become synonymous with powerful, manipulating, controlling and seductive women over the centuries. Perhaps Jehu's declaration over her to her son Jehoram has reinforced this as he declared, "How can all be well as long as your mother Jezebel carries on her countless harlotries and sorceries?" (2 Kings 9:22). Whilst there is nothing in the text of 1 and 2 Kings to indicate either of these specific accusations, they continue to be associated with her.

Let us identify what we do actually know about her, before we consider how her image has been used over the centuries to undermine strong women.

[96] 'Jezebel (1938)' from IMDB <http://www.imdb.com/title/tt0030287/> [Accessed: 06/12/2017]

A short history of Jezebel

Introduction

Jezebel's father was Ethbaal, king of the Sidonians (1 Kings 16:30-33). Josephus says he was also king of Tyre. In other words, he reigned over the Phoenicians. The Phoenicians, of course, were the master traders of the Mediterranean. They were ocean-going and had established bases at Carthage, Cadiz, Marseilles, Palermo and many other places. These were wealthy merchants and, if Hannibal (a Carthaginian descended from the Phoenicians) had not hesitated 7 miles from the gates of Rome, we would today be talking about the Carthaginian or Phoenician Empire and not the Roman Empire.

The worship of the Phoenicians was centred on two deities: Baal and Astarte or Ashtaroth as she is sometimes known. These were the major male and female deities in the Phoenician pantheon. Baal was the storm god, and Astarte was associated with fertility. Astarte is the Sidonian form of Ishtar, one of the Babylonian deities, and she was the goddess of love, and is therefore associated with Aphrodite in the Greek pantheon and Venus in the Roman pantheon.

Ethbaal, whose name means 'Baal's Man', had murdered his way to the throne of Sidon and, as king, was also the priest of Baal. Thus, Jezebel whose name means 'chaste, free from carnal connection', was brought up in a very religious setting where murder was a familiar thing. She would also have been brought up in the lap of luxury which accrued from the trading status of the Phoenicians.

The worship of both Baal and Astarte involved very licentious practices. Examples include the use of temple prostitutes to ensure a good harvest, etc.

As far as the Phoenicians were concerned, Yahweh was just

a local god of the Israelites and the Judaeans. Thus, when, in order to form an alliance between Israel and Tyre, Jezebel found herself as the queen of Israel, she set out to destroy the worship of this upstart god Yahweh. Through Ahab, she established a temple to Baal at Samaria with 450 priests, and a temple to Astarte at Jezreel with 400 priests. She personally provided the food for all of these priests. She then set out to round up and destroy the priests and prophets of Yahweh.

The Plot

In 1 Kings 19:1-3, we first encounter Jezebel face to face just after Elijah's victory on Carmel. Ahab went running (or at least riding in his chariot) back to Jezebel and told her what Elijah had done to the prophets of Baal. As you can imagine, she was not happy. All the work she had done to introduce the worship of Baal and Astarte into the land had been undone. Her response was to threaten Elijah with death within 24 hours.

Something about this threat went deep into Elijah's psyche. It is a little surprising since he had just taken on the prophets of Baal and won. However, in fear he fled and she, for the moment, was thwarted. The threat affected him deeply such that he sunk into depression thinking he was the only one left who was still standing for Yahweh. God assured him otherwise but we can see how this attack went deep into Elijah's soul.

In 1 Kings 21:7-16 Jezebel formulates a plot to steal Naboth's vineyard. We see the sulky Ahab refusing to eat and feeling sorry for himself because Naboth won't give him his vineyard, even though it was against the ancient law for him to do such a thing (21:4-5). I believe it is a good thing for a wife to fight on behalf of her husband and vice versa. However, in this instance, what Jezebel did went beyond

simply fighting for Ahab. Instead, she formulated a plot to murder Naboth and steal the vineyard from those who would inherit it.

The Deuteronomic laws put in place safeguards to protect the people of Israel in the land. One was to ensure that family property remained within the family in perpetuity so that the income of the family could be assured from generation to generation.

In Deuteronomy 17 there are very clear instructions given about how kings should behave. Part of this was not exploiting their fellow countrymen and not misusing their authority to build up their own wealth. In this, Ahab was not acting in the manner of an Israelite king, as laid out in the Deuteronomic law, and giving security to the peasant farmers of Israel. Instead he was acting as a Canaanite monarch who believed that they could take whatever they wanted because they were king. This is exactly what Jezebel tells him to do in v.7.

In despising the law, and in allowing Jezebel to act as she did, Ahab brought a curse on his whole household, and in vv.17-24, Elijah delivered the curse on them that would play out in the following chapters.

In 2 Kings 9:6-10 we see Jehu anointed to slaughter Jezebel and all Ahab's household. In this incident, we see the curse brought by Elijah working itself out. We could actually have seen this work out sooner as Elijah was originally told in 1 Kings 19:16 to anoint Jehu for the work of delivering Israel from Jezebel and Ahab, but it was left to Elisha to do it years later. We are not told why Elijah did not fulfil this instruction of the Lord, but the delay meant that the influence of this woman was allowed to spread to Judah. In addition, her daughter, Athaliah, married the son of Jehoshaphat.

In 2 Kings 9:22, Jehu kills Joram (sometimes rendered 'Jehoram' - son of Jezebel) and throws him in Naboth's vineyard. Joram is the first one to encounter the promised retribution. Jehu makes it clear that he will not stop until he has completed the purpose for which God called him. Thereupon he kills Joram as he is trying to flee. He also kills Ahaziah, King of Judah, Joram's nephew and Jezebel's grandson. Then he rides on into Jezreel.

In 2 Kings 9:30-37, we are presented with an interesting image of Jezebel. On the one hand she is defiant to the end, accusing Jehu of treachery and rebellion against his master. On the other hand, we see her putting on her makeup to greet him. Is this an attempt to seduce him? Or is it simply that she knows her end is in sight and she wants to die looking like a queen? In the same way, Cleopatra, when about to take her own life with an asp, clothed herself in her festal garments. I think this is what we see with Jezebel here as, by this time, she was a great grandmother.

Her end is, to say the least, unpleasant. Thrown down from the top of a palace tower by two eunuchs, presumably dying instantly, her body is torn apart and eaten by wild dogs.

Clash of Cultures

It is not surprising that Jezebel is presented as a 'harlot and sorcerer' by the Biblical writers. Here we have this interloping foreign woman seeking to introduce the worship of alien gods into the land of promise and amongst the people covenanted to Yahweh.

Whilst, I am not seeking to justify her actions – some of them, such as the murder of Naboth were heinous – we can see her acting in complete harmony with the culture and mores of her time. She acts as would be expected of a

Canaanite queen. She expects the word of the king to be law and everybody to give way to him (1 Kings 21:7).

Her marriage to Ahab would have been one to promote a mutually beneficial alliance between Israel and Phoenicia (it is unlikely she would have been consulted concerning the arrangement). The union provided both peoples with military protection from powerful enemies as well as valuable trade routes: Israel gained access to the Phoenician ports; Phoenicia gained passage through Israel's central hill country to Transjordan and especially to the King's Highway, the inland route connecting the Gulf of Aqaba in the south with Damascus in the north. Throughout the narrative, she behaves in accordance with her culture and upbringing. Janet Howe Gaines suggests,

'In contrast to the familiar gods and goddesses that Jezebel is accustomed to petitioning, Israel is home to a state religion featuring a lone, masculine deity. Perhaps Jezebel optimistically believes that she can encourage religious tolerance and give legitimacy to the worship habits of those Baalites who already reside in Israel. Perhaps Jezebel sees herself as an ambassador who could help unite the two lands and bring about cultural pluralism, regional peace and economic prosperity.'[97]

This is, I believe, too sanguine a view of Jezebel as the Biblical text makes clear that her intention was to wipe out the prophets of Yahweh, however, what Gaines's article does touch on is the contrast between her own culture and upbringing and that of Israel. Gaines also contrasts Jezebel with another interloper, Ruth, as follows:

'She represents a view of womanhood that is the opposite of

[97] Janet Howe Gaines, 'How Bad was Jezebel' in *Bible History Daily*

<https://www.biblicalarchaeology.org/daily/people-cultures-in-the-bible/people-in-the-bible/how-bad-was-jezebel/ >

[Accessed: 06/12/2017]

the one extolled in characters such as Ruth the Moabite, who is also a foreigner. Ruth surrenders her identity and submerges herself in Israelite ways; she adopts the religious and social norms of the Israelites and is universally praised for her conversion to God. Jezebel steadfastly remains true to her own beliefs.'[98]

Thus, we encounter Jezebel as a queen seeking to bring her own culture into an alien environment and coming up against those who would oppose her. From the standpoint of both Judaism and Christianity, of course she is seen as evil as she is working against God, however, as a woman and a queen of her time, perhaps her actions were as we would expect.

Conclusion: Symbolic Jezebel

Jezebel has been used as a symbol of all that is evil in womanhood. In Revelation 2:20, her name is attributed to a female prophetess who was clearly leading the church in Thyatira into immorality of some kind, away from the gospel preached by the Apostles. This kind of symbolism has been ascribed to any strong woman over the centuries who has sought to take up a position of authority within the church. But is this fair?

The reality is that, in a patriarchal organisation, if a woman feels a calling and seeks to express it, it will be seen as a threat to any males who believe that they have a monopoly on power. The epithet 'Jezebel' is easy to attribute if we believe that authority is exclusively male.

Another side to this is that a woman, denied access to legitimate authority, may be tempted to use whatever is at her disposal to gain power. This may include intrigue,

[98] Ibid.

manipulation, and sexuality. Unfortunately, the use of such weapons simply reinforces the stereotype and allows men to feel justified in their assessment of such women as Jezebelic.

A further consideration here is that Jezebel plays to the male fantasy of a beautiful, sexual, powerful woman who seduces him and leads him to a bed of carnal pleasure. In this fantasy, the man is the innocent lamb led to the slaughter (this is, of course, how many read the story of the Fall). Powerless to resist her wiles, he is caught up in the spell of the enchantress and is led astray accordingly.

Whatever the truth of these symbols and how they have actually been played out by individual women over the centuries, to label a woman who is seeking to fulfil a legitimate calling on her life as 'Jezebelic' is lazy and inappropriate. It is also potentially obstructive to the will of God being fulfilled in her life or in the life of the church. Too many women over the years have been labelled as a 'Jezebel' simply because they felt called to lead. When an organisation such as a church identifies a woman of strength and determination, rather than condemning her, it should seek to validate the calling and release her to lead according to her gifting and calling.

At present, in twenty first century Britain, we have a female Prime Minister, Home Secretary, Head of the London Fire Service, Metropolitan Police Commissioner and the most senior judge in the UK, and yet, New Churches hold on to the notion that a woman is not fit to lead in the church. Whilst I do not believe we should adopt the culture of this world, and should remain faithful to scripture, surely it is time for the New Churches to revisit this subject? As churches, we should be leading the way in liberating women from a false bondage.

Chapter 7

Women in Scripture - New Testament

Introduction

"Blessed are you O God, King of the Universe, Who has not made me a goy [Gentile]," "a slave," or "a woman."[99]

Such prayers from the Jewish Talmud were enshrined within Jewish law and culture at the point in history at which Jesus was born. Such knowledge makes all the more remarkable how counter-cultural this Jesus the Christ was. As a man who healed women, taught women, talked to women, was followed by women, revealed his resurrected self to a woman, and had high praise for women (Matt. 26:13), Jesus was our unique example.[100]

Those who argue against an egalitarian view, point to the appointment of twelve male disciples as showing that it is men and not women who are called into leadership.[101] However, the twelve disciples were chosen before the church had come into existence. Jesus came primarily to the Jews (Matt. 15:24). Aside from the obvious symbolism with the twelve tribes of Israel, to be respected as a Rabbi Jesus needed at least ten male disciples. With twelve His authority could not be questioned, even among his opponents. This symbolism was no longer needed by the time of the death of

[99] Segal E, *who Has not made me a woman*, <http://www.myjewishlearning.com/article/who-has-not-made-me-a-woman/ >

[100] Forster, *Women*, loc 807

[101] Grudem, *Feminism*, loc 1455

James (Acts 12:1-2), and so they did not need to replace him as they had Judas.[102]

Jesus certainly had followers who were female and who were counted as disciples, even though they were not part of the twelve. Those followers who travelled with Jesus included women who provided financial support (Lk. 8:1-3).[103] Mary sat at the feet of Jesus, a position that denoted discipleship[104] (see below), and when challenged on this by Martha, Jesus kindly but firmly elevated Mary's position above that of the culturally normal gender specific roles,[105] an act repeated when a woman from the crowd shouted 'blessed is the womb that bore you and the breasts at which you nursed' (Lk. 11:27), and Jesus merely replied 'on the contrary, blessed are those who hear the word of God and observe it' (Lk. 11:28). Jesus placed value on learning and following God's word above that of gender or social norms. Jesus washed feet (Jn. 13:5), made breakfast, (Jn. 21:12), taught his followers to serve rather than being served, (Lk. 9:16), and cuddled infants (Lk. 18:15), all of which were the traditional roles of either females or servants.[106] Whatever else was involved in the ministry of Christ, it certainly was not to reinforce the subordination of women.

In fact, the uses made of male and female characters in the gospels are remarkably parallel. When teaching on marriage, Jesus emphasised the equal treatment of both men and women (Matt. 5:32; Mark 10:11-12).[107] Martha echoed Peter's great confession of Jesus as the Christ (Matt. 16:16; Jn. 11:27-

[102] author unknown, *The Twelve apostles were all male*, <http://newlife.id.au/equality-and-gender-issues/the-twelve-apostles-were-all-male/>

[103] Belleville, *Two Views*, loc 2640

[104] Forster, *Women*, loc 667

[105] Forster, *Women*, loc 674

[106] Forster, *Women*, loc 759

[107] Blomberg C, *Two Views*, loc 2658

28). The parables too are given in echo, one man, one woman: two that represent God seeking the lost with zeal and persistence (Lk. 15:8-10; 15:3-7);[108] two that represent prayers answered through persistence (Lk. 11:5-8; 18:1-5);[109] two that represent entering into the kingdom of God, or not (Matt. 25:1-13; 14-30);[110] and two that represent the growth of the kingdom (Matt. 13:31-32, 33-34).[111] There are two men in bed, and two women grinding, one from each is taken, the other left, each showing a balance of men and women (Lk. 17:34-35).[112]

Unable to testify in court, their testimony held little weight in the wider world of the time, and hence they were omitted from the witnesses to the resurrection mentioned in 1 Corinthians 15, however, to the apostles who were the very beginning of the church, women were the first witnesses to the resurrection of Christ. The significance of this cannot be underestimated. Women were to become a key part of the birthing of the church, unprecedented for the time. They were present on the day of Pentecost (Acts 1:14; 2:4), and had the Spirit poured out upon them equally (Acts 2:17-18).

The resulting spiritual gifts were, and continue to be, given indiscriminately by God, regardless of gender (1 Cor. 12:11; 11:5).[113] Because of this we see women in the role of deacon (Romans 16:1; 1 Tim. 3.11).

In Romans 16, Paul continues to mention prominent women who have been fellow workers with Him for Christ. He begins with Phoebe whom he identifies as a deacon of the church in Cenchreae which was a port on the Eastern side of

[108] Forster, *Women*, loc 594

[109] Forster, *Women*, loc 599

[110] Forster, *Women* loc 602

[111] Forster, *Women*, loc 606

[112] Forster, *Women*, loc 601

[113] Blomberg, *Two Views*, loc 2396

the Corinthian Isthmus. We know from Acts 18:18, Paul had his head shaved in Cenchreae, but it seems he also established a church there as Pheobe is from that church. It is to her that he has entrusted the carrying of this letter to the Romans.

Deacons, of course, were appointed to carry out the practical duties in the church and work alongside the elders accordingly. Some of them we know moved into their own ministries, as per Philip the evangelist in Acts 8. In this instance, Phoebe was used by Paul for this important role of conveying this most significant of epistles to the Romans to prepare the way for his own coming.

He also identifies that Phoebe has been a benefactor to the church and to Paul himself (16:2). In other words, she had helped others out of her substance and was therefore both wealthy and generous.

Next, Paul mentions Priscilla and Aquila, Priscilla being named first despite being the female. They were commended for being fellow workers. He also tells us that they risked their lives for him. Of course, we do not know about this specific incident but we do know that they were committed both to the gospel and to Paul. As a result, he says, 'All the churches of the Gentiles are grateful to them'. We are too, because, without their intervention, he may not have lived long enough to write his epistles. I will come back to Priscilla below.

He then commends Mary for her hard work. We do not know exactly what she did, but Paul identifies that her work was specifically for the Roman church.

Next comes Junia, a Jewish lady, who, rather than being considered a lesser apostle due to her gender, was considered outstanding among the apostles (Rom. 16:7). Paul mentions that she and Andronicus are both long time

believers (they were in Christ before him) and were in prison with him. Paul Benger has written an excellent article on 'who killed Junia', examining how, over the centuries, the notion of her being an apostle has been eradicated from the church.[114]

Next come Tryphena and Tryphosa (16:12) who are commended for their hard work. These two were probably twin sisters from a noble Roman family since their names are specifically Roman and the practice of such families was to give twin daughters names that derived from the same root. In this case that root meant 'delicate' or 'dainty one'. However, it is not for being dainty that Paul commends them but for their hard work probably as deacons in the Roman church.

Next come Persis whom Paul describes as 'my dear friend'. Again, she is one whom Paul commends for her hard work.

In v.15, we have two women mentioned: Julia and the unnamed sister of Nereus. Julia is a name associated with the Imperial household and so there is a chance that she was a significant woman in Rome.

All of these women are picked out for specific greetings and commended for the work they were carrying out in the Roman church. Since this letter is written prior to Paul visiting Rome, he had either come across these women elsewhere in his ministry and they had later moved to Rome, or else their reputation had spread throughout the church due to the hard work they were carrying out. Either way, they were all significant enough for specific mentions.

It is often mistakenly believed that Paul looked down on women, however, he has the highest praise for women, commending twice as many women as men. Paul truly had

[114] Paul Benger, <https://paulbenger.net/2016/09/04/theology-who-killed-junia/>, [accessed: 06/03/2018]

Christ as his lead. He rejected cultural norms in his interaction with women, talking freely with them. Most household codes at the time would be addressed to the head, however, Paul calls on the child, the slave, and the woman, to regulate their submission voluntarily, something he requires of us all regardless of gender (Eph. 5.2).[115]

Let us examine some of the principle women of the New Testament (we will consider Mary in the following chapter).

Elizabeth

What do we know about Elizabeth? Well firstly, her name means 'God is my oath', or 'my God is abundance'. Either way, there is the sense of trusting God for provision and for fulfilment of his promises. It is ironic, therefore, that Elizabeth is childless. It would appear that God has not fulfilled his promise to the righteous to make them fruitful. This is even more surprising in the light of what else we are told about Elizabeth.

Firstly, we are told that she was, like her husband, a descendent of Aaron and from a priestly line. Next, we are told that both of them were 'righteous in the sight of God, observing all the Lord's commands and decrees blamelessly'. You would have expected that these, of all people, should have merited the covenantal favour of the Lord for Israel. We are told in Deuteronomy 27:2-6:

> "All these blessings will come on you and accompany you if you obey the Lord your God:
>
> You will be blessed in the city and blessed in the country. The fruit of your womb will be blessed, and the crops of your land and the young of your livestock – the calves of

[115] Keener C. S, *Man and Woman*, Dictionary of Paul and his Letters, (InterVarsity Press: Leicester, 1993), p. 587

your herds and the lambs of your flocks. Your basket and your kneading trough will be blessed. You will be blessed when you come in and blessed when you go out."

Despite their obedience, and despite the shame and humiliation that would come upon Elizabeth specifically for her barrenness, they had not been given the gift of children. It was the dream of every woman in Israel to be the mother of the Messiah in fulfilment of the promise to Eve, but it was not possible that such a dream would be fulfilled in the life of Elizabeth since she was now 'past the age of childbearing' (v.7).

The response of Elizabeth, once God does hear her prayers is, 'The Lord has done this for me…In these days he has shown me favour and taken away my disgrace among the people' (Luke 1:25). She was in no doubt as to the source of her miraculous ability to conceive beyond the age of childbirth.

In vv.39-45, we see Mary arriving at Elizabeth's home. It is amazing that pre-natal John is able to respond to the arrival of pre-natal Jesus in the home. His leaping for joy triggers a Holy Spirit outpouring from Elizabeth in which she greets Mary the 'mother of my Lord'. This is significant in that she is the first person in the narrative to recognise Jesus. The term 'Lord' here, kyrios, was used in the Septuagint to translate 'Yahweh' from the Hebrew, so effectively, Elizabeth is recognising the baby in Mary's womb, not just as the Messiah, but as Yahweh himself.

We can compare this with Psalm 110:1 'The Lord said to My Lord…'. Elizabeth also recognises that Mary was the one to fulfil the prophetic word to Eve: 'Blessed is she who has believed that the Lord would fulfil his promises to her'. Such a privilege Elizabeth had to be the first one to greet the Messiah.

In the final episode recorded concerning Elizabeth, we have the birth of John itself (vv.57-66). Notice how her neighbours and relatives share in her joy at finally having a baby (v.58). In having children, we share in the creative nature of God and fulfil the divine mandate given to humanity to 'fill the earth and subdue it'. There is a divine joy that accompanies such moments.

Elizabeth is insistent and determined in this passage: 'No! he is to be called John' (Luke 1:60). This was completely against the culture of the day, but Elizabeth was more determined to obey God than obey culture despite what anyone might say.

Mary & Martha

We encounter Mary and Martha in three distinct places in the gospels: Luke 10:38-42, John 11 and John 12. We will consider these encounters in turn. However, first let us contemplate the background to these stories.

Mary and Martha lived with their brother Lazarus in Bethany. From Luke 10:38, we are told that the house belonged to Martha, which would indicate that she was the oldest of the three siblings. Clearly, their parents are not around, which would suggest women not in the first bloom of youth. The fact that she is in charge of the house would also suggest that Lazarus was the youngest of the three. Since a Jewish man was not considered a senior until the age of 30, Lazarus was probably in his twenties and was under his sisters' authority.

We know little else about this household except that they obviously had a good enough income, probably from the land, to offer hospitality, and specifically they extended that hospitality to Jesus and the disciples whenever they were passing through town. This house became a place of respite

and sanctuary for Jesus whenever he needed it, away from the hustle and bustle of ministry.

Luke 10:38-42

In order to understand what is going on in this passage, we need to understand something of the culture. An easy mistake to make here is that Jesus is condemning Martha for being practical rather than spiritual. That is not quite true.

In the culture of the day, to provide hospitality to a guest was of utmost importance. Not to show hospitality was to bring dishonour upon the house. Martha's concern here is that Jesus and his disciples are properly catered for. As the owner of the house, it was her duty to make sure this was so. Under normal circumstances, it was expected within the culture that Mary should have been helping her.

However, what is easy to miss here was that Mary was at Jesus' feet. This was the position of a disciple. What is so shocking about this is that women were not expected (or allowed) to learn in this way. In the synagogue they had their own separate area at the back and were not allowed to be involved in the teaching or discussions concerning the Word. In the temple, they had no part to play in the worship of Yahweh except to observe from the Court of the Women. Essentially, they were excluded from the religious and spiritual elements of the people of Israel.

What is radical about Jesus is that he broke all such restrictions and allowed women to become his disciples. We know from Luke 8:1-3 that a whole group of women accompanied the disciples, ministering to their needs. The implication is that they were also there to be discipled.

In this passage, Mary has taken full advantage of this new-found freedom that has been opened up to her through

Jesus. She is taking every opportunity to sit at the feet of Jesus and to receive of his teaching – something that had been denied her up until this point. Martha on the other hand is so distracted with the practical service that she has failed to grasp the freedom to learn that is now hers.

Jesus is not saying that to learn is better than to serve. Both are required. However, given the unique and time-bound opportunity that they had to sit at his feet, this was the most important thing on this occasion. Jesus does not condemn Martha for her service, but rather gently rebukes her because she wants to restrict Mary's freedom to be a disciple.

John 11

This incident begins by identifying each of the family members in turn. In v.2, it is Mary who is specifically mentioned and John highlights an incident which he will come back to in the following chapter. In v.1 it is Lazarus that is highlighted. In v. 5, it is Martha who is mentioned first as John highlights Jesus' love for these three.

It is this that the sisters pick up on when they send word to Jesus: 'The one whom you love is sick' (v.3). That being the case, his delay is inexplicable to the two sisters who both challenge Jesus by saying 'If you had been here my brother would not have died' (v.21 & 32).

The two sisters respond to Jesus' arrival completely in character. Martha, ever the practical one, goes straight out to meet the Lord, but Mary, the contemplative one, stays at home (v.20). Martha is in the place of faith and yet cannot conceive yet what it is that Jesus could do for her brother. On the one hand she affirms that whatever Jesus asks for will be done for him (v.22), while at the same time, when Jesus says that her brother will rise again, she assumes that he is talking

about the ultimate resurrection that we will all experience (v.24). Jesus affirms that he has power over life and death through his declaration, 'I am the resurrection and the life...' and calls forth from her a response. In reply, she affirms her faith in who he is – the Messiah, the Son of God (v.27).

Essentially, Jesus has led Martha on a journey. She began by focussing on his absence allowing her brother to die and ends up affirming her belief in him as the answer to all things. She is lifted from the immediate to the ultimate. Her focus moves from herself to the Lord. Even while watching to see what Jesus is going to do, Martha remains the practical one. When Jesus asks for the stone to be removed, she expresses her concern that Jesus will just face a bad odour. In response, Jesus reminds her to focus on God and his glory.

In contrast with Martha, Mary waits for the call of the Lord (v.28-29). Her response on meeting him is to return to that position where we last saw her – at the feet of Jesus. This time, however, it is not to learn, but simply to express her grief. She is overwhelmed with her feelings and can only throw herself at the feet of Jesus. In response to both of them, Jesus did the unexpected and brought back their brother from the dead.

John 12:1-8

Suddenly, in chapter 12:1-8, we enter the last week of Jesus' life – the run up to the Cross.

In this account of the anointing of Jesus at Bethany, which is shared with Matthew and Luke, only in John is the woman identified as Mary, and only in John is the dissenting disciple identified as Judas Iscariot.

In the previous incident – when she sat at the feet of Jesus – the context was a meal. Once again, in this incident, the

context is a meal. Lazarus, Mary and Martha are hosting a supper for Jesus.

Imagine the scene: the disciples are milling around, some sat at table, others chatting amongst themselves. Jesus is chatting with Lazarus (perhaps talking to him about what happened when he was dead), Martha is busy in the kitchen as always. Mary arrives in the room with a very obviously expensive alabaster jar. She breaks it open and pours it on Jesus' feet. Suddenly, the senses of everyone are overwhelmed by the wonderful fragrance that bursts forth upon them. The whole house smells like a perfumery, and as the eyes of everyone fall on Mary, they see her gently and lovingly wiping the excessive liquid from Jesus' feet with her hair.

To put this into context, Nard, an aromatic herb grown in the foothills of the Himalayas, was imported and used to scent the couches of kings, was used to anoint the heads of royalty at their coronation and was used for embalming corpses. (Anointing oil for the King). Usually, Nard was only put on the feet when a body was being anointed for burial.

This nard would have cost the equivalent in today's money of a year's wages, and yet, such a price was not too much for Mary to pour out as on offering of love and worship to Jesus. This is extravagant worship! She broke the vessel and, in a moment, it was gone leaving the heady fragrance which filled the house and overcame the senses of all within range.

For Mary, this perfume represented her life savings – investing in precious things was a method of storing up treasure for retirement or for emergency. Mary sacrificed her future – gave of her most precious resources – so that she could perform a **single** act of worship towards Jesus. He was of far greater value and worth to Mary than her own life. As she walked away from the couch, the fragrance would have

accompanied her and would have stayed with her for many hours / days, lingering in her hair.

In this act, Mary broke all cultural boundaries. She, an unmarried female, was in close physical contact with a man. She performed this act publicly, regardless of censure or scorn. She acted without common prudence in giving away her life savings. She stepped beyond expected norms in order to express her worship. That is why Jesus said, in Matthew 26:13, 'What she has done will also be told in memory of her'.

Philip's Daughters

In Acts 21:8-9, Paul stays at the house of Philip the Evangelist in Caesarea. We saw Philip arrive in Caesarea at the end of Acts 8:40. Clearly, he settled there and started a family. When Paul arrives at his house some years later, Philip has four grown up unmarried daughters. He fact that they are 'unmarried' is significant here because it would suggest that they had committed themselves to ministry instead of to marriage. We are also told that they were all prophets.

The significance of these women being prophets is that the prophetic ministry in the early church was trans-local. In other words, those exercising it would travel around from church to church bringing the prophetic word. The Didache (11:1-13:8) gives very clear instructions about this and how a prophet should be received.[116]

These women are recognised as operating in one of the Ephesians 4 ministries which are Christ's gifts to the church.

[116] *Didache* Tr. By J.B Lightfoot < http://www.earlychristianwritings.com/text/didache-lightfoot.html> accessed [07/12/2017]

Lydia

From the text (Acts 16:12-15, 40 Philippians 1:1-11), we know very little of Lydia. We do know the following however:

She was from Thyatira. As it happens, Thyatira is in the region of Lydia in Asia Minor so it may be that Lydia is not her actual name but signifies where she was from – a 'Lydian'. Thyatira was famous for dyeing purple cloth. This of course was cloth used by emperors and so it's ideal location for this purpose brought much prosperity to the city. Thyatira is one of the places written to in the letters of Revelation and not in the best terms. The church there contained a woman whom the letter identifies as a 'Jezebel'.

We know that Lydia was a seller of purple cloth. Her trade had taken her to Philippi in Greece, which is where the incident recorded in Acts occurred. Such cloth was only sold to the elite of Roman society. It was made from the juice of certain crustaceans – it took thousands of crustaceans to make a yard of purple and was therefore literally worth its weight in silver. It was the Gucci handbag or Prada shoes of its time. The dye was fixed in the cloth using ammonia – available from urine. Makers of purple cloth had buckets outside their homes for people to use on the way past. Thus, the making of purple cloth was a very smelly process not carried out by the elite themselves, but by lower status citizens. So, although Lydia was probably fairly wealthy from this trade, she was not part of the upper echelons of Thyatiran or Philippian society.

We also know from the text that she had a house in Philippi. She probably also had one in Thyatira and would move back and forth between the two of them, selling her cloth. From all of this, we know that she was a successful business woman and it would seem from Acts 16:40 that the burgeoning church in Philippi met in her home.

We know from v.14 that she was 'a worshipper of God'. This means that she was already a worshipper of Yahweh. We do not know if she was of Jewish descent or whether (more likely) a proselyte (a gentile convert to Judaism).

The key to understanding Lydia is in one verse: 'The Lord opened her heart to respond to Paul's message' (v.14). From that brief moment flowed her faithful service and the establishment of a church in her home. She was the first convert in Europe and opened the door for the next two thousand years of church history.

Lydia is a model of a liberated woman: a successful business woman, worshipper of God, church leader and supporter of Paul – the greatest of all theologians.

Priscilla

Priscilla first crops up in Corinth with her husband Aquila. They are amongst those Jews who were deported from Rome by Claudius around AD50. According to Suetonius, "since the Jews constantly made disturbances at the instigation of Chrestus, he [the Emperor Claudius] expelled them from Rome." Most historians would suggest that the 'Chrestus' referred to here is in fact Christ and that the trouble between the believing Jews and the unbelieving Jews caused Claudius to banish the lot of them. Thus, Priscilla and Aquila found themselves in Corinth.

Aquila (and probably Priscilla too) were natives of Pontus, a region to the south of the Black Sea in what is modern day Turkey. However, since most people in the Empire spoke Greek, they would have been comfortable in any place in which they could ply their trade. It seems, from Acts 18:3, they were tentmakers like Paul, or to be precise, makers of tent material.

Paul stayed in Corinth for about 18 months and then took Priscilla and Aquila with him when he sailed for Ephesus. There he installed them to look after the newly established church while he went up to Jerusalem, promising to return. Clearly, by this time, he was confident enough in their ability and leadership to leave them in charge of the church.

It was while Priscilla and Aquila were in Ephesus that a fiery young preacher by the name of Apollos came across their path (Eph. 18:24-26). It seems that he was well educated and a good orator, but that he had a defective understanding of the truth. He knew of the baptism of John and was therefore looking for the Messiah but did not know that he had come in the person of Jesus. Notice, it is both Priscilla and Aquila who 'explained to him the way of God more adequately'.

At this point, Priscilla and Aquila disappear from the narrative. When Paul wrote 1 Corinthians, he was still with Priscilla and Aquila and most scholars believe he wrote it from Ephesus. By the time Paul wrote his epistle to the Romans, they were back in Rome. When Paul wrote 2 Timothy, his very last letter written not long before his death, he asks Timothy to greet Priscilla and Aquila. Most scholars believe that Timothy was in charge at Ephesus at this time so it seems that their stay in Rome was short lived and they were soon back in Ephesus working alongside Timothy. Perhaps, with all the persecution in Rome, this was a better location for them.

We do not know much about them or what their ministry was. Clearly, they functioned as church leaders together. It is very unusual in the new Testament to have a husband and wife team cited so specifically as they are. Their ministry was a joint effort and it is together that they are shown as teaching Apollos.

Priscilla was not a stay at home wife, or even just a tent maker. She shared with her husband, Aquila in all aspects of

ministry and church leadership. In 1 Corinthians 16:19, we are told they were also leaders of a church that met in their home. Clearly, they were not without their substance since churches tended to meet where there was enough room for plenty of people.

So, Priscilla and Aquila were congregation leaders in a much bigger church in the city of which Timothy was the main leader.

Conclusion

We encounter many women in the New Testament who are simply names. The ones we have considered above, and the ones listed in such places as Romans 16, demonstrate the full acceptance that women had in the early church. Clearly, they played a full and complete role alongside the Apostles in many locations.

Richard Bradbury

Chapter 8

The Deification of Women – the Mary Cult

Introduction

The last two thousand years have seen the rise of the cult of Mary. Whilst we could spend some time considering the character of Mary from the Bible, that is not the focus of this book. Rather we will consider all that has grown up around her which has reinforced the male stereotypical view of the role of women in society and in the church.

Within the New Churches, the symbol of the Virgin Mary plays very little part in our theology and receives even less of our attention, except at Christmas, or in consideration of the women at the cross. The theology of our Catholic sisters and brothers in this respect would be considered as a distraction at best and heretical at worst – as Protestants we would deny the Immaculate Conception, the Assumption of Mary and the eternal virginity of Mary - however, this does not mean that the interpretation of the role of Mary within the gospels and in the life of Christ has not been influential in forming or reinforcing a particular view of women that has been played out in the intersexual relationships within our communities. It is this view that will be the focus of this chapter.

Below I will explore the symbol of Mary as compliant woman / virgin, and as the model of maternal love, giving consideration to the implications of these perspectives on the behaviours and attitudes of women and men in our communities.

Mary as Compliant Woman / Virgin

Much of what is cited by, for example, Mary Daly concerning the misogynistic view of the nature of women: 'the propensity for being temptresses, the evil and matter-bound "nature" of the female, the alleged shallowness of mind, weakness of will, and hyper-emotionality', is alien to my Protestant understanding of women, although I am sure that has been a sub-conscious influence, pervasive as it is in society as a whole.[117] Rather I have been brought up with the notion that men and women are equal, were co-responsible for the Fall, and shared in its consequences. Part of that consequence was an inherent submissiveness on the part of women to male authority (Genesis 3:16). Thus, in the teaching I have received, male headship is legitimized as a consequence of the Fall.

With respect to female and male roles, I have been taught that 'men and women are redemptively equal but functionally different'.[118] Fiorenza cites this view as 'the expression of "orthodox" anthropology'.[119] Thus, complementarian teaching suggests that, just as there are biological differences between women and men that make certain roles (such as childbirth) impossible for men, so the role of headship is one that is given exclusively to men because they are 'divinely equipped' to fulfil this role. As we saw in chapter 4 above, 1 Corinthians 11:3 and Ephesians 5:22-33 are cited as confirmation of this.

This teaching defines a sphere for men and women within which it is legitimate for them to operate and by implication also excludes them from other roles. Thus, the roles that

[117] Ibid., p.76

[118] I cannot attribute this statement to any one person but it is something that has been repeated in teaching I have received over the years.

[119] E.S. Fiorenza, *In Memory of Her: a feminist theological reconstruction of Christian origins*, (2nd Ed.), (London: SCM Press, 1995), p.9

women can fulfil within this teaching are that of mother, submissive wife and support for her husband who assumes the role of leader in the family and in the church. As Ruether says in considering the Puritan response to the Song of Songs (the roots of non-conformist Protestant theology generally are in Puritan theology), 'women too had some authority, delegated by their husbands, over children and servants. But the metaphor reinforced the female's primary role and identity as passive, submissive partner in authority relationships'.[120] Elizabeth A. Johnson refers to these as 'the sacred texts and laws that keep women in a subordinate role'.[121]

Clearly, this teaching supports patriarchy within the particular spheres of the home and the church, and in society in general. As Mary Daly says, 'Protestant obliteration of the Virgin ideal has to some extent served the purpose of reducing "women's role" exclusively to that of wife and mother, safely domesticated within the boundaries of the patriarchal family'.[122] As Johnson confirms, 'the system, a pattern of relationship, predetermines the roles men and women play'.[123]

When considering the role of Mary within the incarnation story, particularly as it appears in Luke's gospel, feminist theologians see a reinforcement of this sexual stereotype being played out in the narrative. Firstly, they identify the young girl, Mary, submitting to the patriarchal system of her day, engaged to a man, Joseph, and the narrative makes it very clear that she was still a virgin (Luke 1:27) – the sign

[120] Rosemary Radford Ruether, *Sexism and God-Talk* (London: SCM Press, 1983), p.126

[121] Elizabeth A. Johnson, 'Women's Place: Two conflicting views guide the church's position on women and have from the very beginning and therein lies hope', *Boston College Magazine*, Summer 2004

http://bcm.bc.edu/issues/summer_2004/features.html [accessed: 27/03/2012]

[122] Daly, *Beyond God the Father*, p.85

[123] Johnson, 'Women's Place'

that she was under male authority and that her sexual freedom had been limited accordingly.[124] Then she is seen submitting to the higher male authority of God, personified in the angel Gabriel, who informs her that she is soon to become pregnant, not by Joseph, but by God himself. Instead of protesting such a relationship as illegitimate, Mary simply complies with this revelation, submitting as 'the maidservant of the Lord' (Luke 1:38 NKJV), 'whose most celebrated utterance is 'Let it be done to me according to thy will'.[125]

According to Feminist theologians, from a Protestant perspective, this narrative reinforces the role of women within patriarchal society as we see Mary, first submitting to her husband, but then totally surrendered to the male God and the male angel (angels are, of course, without sex or gender, but they appear as male figures throughout scripture). Her role is not to question such authority but to submit to it. Thus, she is cited as a role-model for all Protestant women. Mary is thereby the 'receptive and / or mediating principle of the male sovereignty'.[126] Mary is presented in our tradition as a woman to emulate in her submission to God and to her husband reinforcing the 'domesticated' sphere allotted to her.

Mary as the model of motherhood

Turning to the image of Mary at the cross in John 19:25-27, we see Mary as loyal mother, remaining faithful to the end. This is in contrast with Matthew 12:46-50 where Jesus

[124] See discussion on Virginity in Mary Rose D'Angelo, 'Veils, Virgins, and the Tongues of Men and Angels: Women's Heads in Early Christianity, in *Women, Gender, Religion: a reader*, ed. by Elizabeth A. Castelli with assistance from Rosamond C. Rodman (Houndmills, Basingstoke, St. Martin's Press, 2001), pp.389-419 (pp.400-408)

[125] Naomi Goldbenberg, 'The return of the Goddess', in *Religion & Gender*, ed. by Ursula King (Oxford: Blackwell Publishers, 1995), pp.145-163 (p.150)

[126] Ruether, *Sexism and God-Talk* (London: SCM Press, 1983), p.117

appears to reject his mother and brothers. However, at the cross we see Jesus handing responsibility for his mother over to John and, if tradition is to be believed, John carried this responsibility seriously, taking her to Ephesus with him, her purported final resting place.

Commenting on Genesis 2:21-24, Matthew Henry suggests that 'the woman was made of a rib out of the side of Adam; not made out of his head to rule over him, nor out of his feet to be trampled upon by him, but out of his side to be equal with him, under his arm to be protected, and near his heart to be beloved.'[127] This quote, which expresses the Protestant position with respect to men and women, suggests boundaries to female authority within the female-male relationships and prescribes to the male role the authority and protection of women. Such a notion is reinforced by the image of Mary at the cross where we see Jesus assigning the protection of his mother to John and lends weight to the patriarchal nature of the church, reinforcing male headship.

In contrast, Matthew (28:1), Mark (16:1) and Luke (24:10), all place Mary as one of the women at the tomb on Easter morning, intending to fulfil her matriarchal duty of preparing the body of her son for burial (although her name is absent from John's account in this respect). Luke also places her in the Upper Room at the prayer meetings before the Day of Pentecost (Acts 1:13).

These latter images of Mary, whilst not challenging the stereotypical role of 'mother' do open up a new possibility of seeing Mary as an important member of the early church – a fact often overlooked in the emphasis on Mary as 'Mother of God', or as the 'new Eve'.[128] Mary here is pictured as a fully operational member of the disciples. Fiorenza suggests that

[127] Matthew Henry, *Commentary on the Whole Bible Volume I (Genesis to Deuteronomy)* Kindle Location 1147 [Kindle]

[128] Kari Elisabeth Borresen, 'Women's studies of the Christian Tradition' in *Religion & Gender*, ed. by Ursula King (Oxford: Blackwell Publishers, 1995), pp.245-255 (p.248)

the women in this part of the narrative 'suddenly emerge as the true disciples' and as 'the true Christian ministers and witnesses'.[129] This is in contrast with the male disciples who had deserted Jesus during his passion. Thus, if the image of the Virgin Mary, is deconstructed (the model that makes Mary '"immaculately conceived"[130] in order to be worthy to become the Mother of Jesus' - a model that is unattainable for all women[131]), we see a very human Mary who, not only shared the grief of those who loved Jesus, but became a formative (and specifically named) member of the Early Church. Fiorenza goes on to suggest that 'the New Testament sources provide sufficient indicators for such a history of early Christian beginnings, since they mention that women were both followers of Jesus and leading members of the early Christian communities'.[132]

The issue in the New Churches has been that we have ignored such indicators in the light of a theology that has insisted that 'leadership is male'.[133] In the same way, we have ignored the many references to female leaders throughout the New Testament (for example, in Romans 16), choosing instead to emphasise a 'doctrinal understanding of Scripture'.[134]

Conclusion

The greatest problem for Christian women within the New Churches as it stands is theological not structural – the

[129] Fiorenza, *In Memory of Her*, p.xliv

[130] The Immaculate Conception, according to the teaching of the Catholic Church, is the conception of Mary free from original sin by virtue of the merits of her son Jesus Christ. The Catholic Church teaches that God acted upon Mary in the first moment of her conception keeping her "immaculate". This is often confused with the conception of Jesus by Mary.

[131] Daly, *Beyond God the Father*, p.82

[132] Fiorenza, *In Memory of Her*, p.1

[133] This is the title of a book by Christian author David Pawson that has been used by many within the New Churches to reinforce the traditional patriarchal position concerning leadership in the church.

[134] Fiorenza, *In Memory of Her*, p.lii

doctrine of male headship, held generally within the New Churches, limits and restricts the roles and functions that women can perform in the home and in the church. This position is reinforced by the image of Mary as 'handmaiden of the Lord' and as 'loyal mother', as suggested above and is used as an example of female submission.

One of the problems encountered when challenging this view, in my opinion, as identified by Linda Woodhead, is the commitments of feminist critiques of Christianity. She suggests that 'many versions of feminist critique do in fact involve very large-scale commitments, commitments to an entire world view or spiritual system which is incompatible with Christianity'.[135] She goes onto say that, 'in its belief that everything, including the sovereign God, can and must be judged by the application of an independent standard, feminist theology shows again its debt to the Enlightenment project'.[136]

It is the Enlightenment approach, and particularly the historical-critical method which most within the New Churches would reject, and therefore any argument for a leadership position for women based on this approach would also be automatically rejected.[137] The challenge for both men and women in the New Churches therefore is to

[135] Linda Woodhead, 'Spiritualising the Sacred: Critique of Feminist Theology', in *Modern Theology* 13, 2nd April 1997, pp.191-212 [pp.196-197]

[136] Ibid., p.197

[137] The Enlightenment approach, as regards to scripture, includes the 'demythologising' of the Bible. It begins with the notion that God was like a great clockmaker who, at creation, wound up the universe and left it to run its course, playing no further part in it. Thus, any suggestion of the supernatural, or of God's interaction with his creation are automatically dismissed. Also, any notion of the Bible bringing God's revelation to humanity is also ignored. This leads to many of those who come under the influence of the Enlightenment (I include the likes of Harnack, Bultmann, et al, as well as feminist theologians) dismissing the notion of the inspiration of scripture and leads them instead to try and identify the motive of each writer. The commitment to this thinking means that the Bible is no longer seen as the source of our faith and practice, but rather is a piece of writing to be analysed and, any ideas within it that do not line up with modern values, dismissed.

distinguish between cultural constraints and spiritual principles within the canon of the New Testament such that women can be liberated from the patriarch dominated position espoused by those constraints, whilst remaining true to the perceived spiritual principles within the text. Key to this is a re-examination of the texts that reveal the role of women in the Early Church, as suggested above.

The problem is not structural because, by their very nature, the New Churches are organic rather than organisational. This means that governmental issues are not prescribed by a central body but are worked out within a local congregation. Thus, if that congregation comes to believe that women have an equal part to play in the governmental and teaching roles of the church and family, this can be (and in some places already has been) implemented quickly and without issue.

I believe more work needs to be done regarding identifying the manner in which both women and men carried governmental roles within the New Testament which will be persuasive to those who wish to remain true to scripture but want to see the freedom and liberty expressed in the baptismal formula of Galatians 3:28 available to all within the New Churches. I will make some suggestions concerning how this could be implemented practically below.

Chapter 9

The Objectification of Women

Introduction

The view with which society considers women flows out of their objectification by men.[138] Essentially, this is the notion that equates a woman's worth with her body's appearance and sexual functions as viewed by men.[139] Women have bought into the role this casts them in, perhaps understandably, however, in order for the role of women within society to change, not just in appearance, but in essence, the objectification of women needs to be broken.

In this chapter, we will consider what has led to this objectification, reflect how it has shaped society and culture, and suggest what might be done to break it.

Defining Objectification

The objectification of women flows out of man's essential sexual needs which have imposed upon women various idealised characteristics which are physical, social, and cultural, and which are identified as desirable for all women.

138 Much has been written about the objectification of women by men, both in popular culture, and in academia. The following article articles are examples that I found whilst researching this subject. Robin Tran, '4 ways men are taught to objectify women from birth' in *Everyday Feminism* <https://everydayfeminism.com/2016/06/men-taught-to-objectify-women/> [accessed: 06/03/2018]. Dawn M. Szymanski, Lauren B. Moffitt, Erika R. Carr, 'Sexual Objectification of Women: Advances to Theory and Research 1ψ7'(22/09/2010) in *The Counselling Psychologist* < http://journals.sagepub.com/doi/pdf/10.1177/0011000010378402> [accessed: 06/03/2019]

139 Szymanski, 'Sexual objectification of women', p.1

Robin Tran suggests that, 'we're taught that an entire gender exists purely to satisfy others' needs'[140]. In this chapter, whilst acknowledging that some of these idealised characteristics will vary from culture to culture, the focus here is on the Western world.

Physical attributes include a certain figure and facial features to which women should aspire in order to be desirable to men. Objectification of women takes place in the sexually oriented depictions of women in advertising and media which present an image of the desirable woman for all women to aspire to.[141] The conformance of women to these attributes flows out of patriarchalism and out of the dysfunctional relationship between men and women resulting from the Fall.[142] In other words, women conform to male desire because of the need to be accepted by men in a male dominated society. Some would suggest it is even a throwback to evolutionary development whereby the particular female features that men find desirable are associated with health and the ability to nurture children in order to propagate the species.

These attributes comprise a woman's beauty in the eyes of a man and set a standard for women to aspire to if they want to be desirable to men. However, this is where the fundamental problem lies. Beauty becomes the determiner of desirability which, in turn, means conforming to this set of male-defined physical attributes. These attributes were idealised in the Greek world through images of Aphrodite and Artemis, etc. Such idealised women became the objects of male (and female) worship and were set as points of aspiration within a patriarchal pantheon (Zeus was the male

[140] Robin Tran, '4 ways men are taught to objectify women from birth'

[141] Sut Jhally, (director) (1997), 'Dreamworlds II: desire, sex, power in music' (Documentary). USA: Media Education Foundation

[142] Catharine MacKinnon, *Only words* (Cambridge, Massachusetts: Harvard University Press, 1993)

head of the gods). Radford Ruether discusses in detail how the earliest of divinities were female images.[143]

The fundamental problem with this is that it reinforces the notion of women existing as the object of male worship and desire, rather than as individual human beings in their own right. Female sexual objectification by a male involves a woman being viewed primarily as an object of male sexual desire, rather than as a whole person. Discrete identity is subsumed under the projection of outward beauty, instead of as a function of the essential self. Life is lived to fulfil male expectations in order to be found desirable to achieve a sense of self-worth, significance, acceptance and security. Sexual objectification of women has also been found to negatively affect women's performance, confidence, and level of position in the workplace.[144] Sexual objectification can also lead to negative psychological effects including eating disorders, depression and sexual dysfunction, and can give women negative self-images because of the belief that their intelligence and competence are currently not being, nor will ever be, acknowledged by society.[145]

The fashion and makeup industries are founded on the notion that women have to conform to Western ideals of beauty in order to be acceptable, not only to men, but to society as a whole. This makes them subordinate to the wishes and desires of the men and thus takes away from them true freedom of expression to be whatever they desire to be regardless of male stereotyping.

In terms of social and internal characteristics, historically, men have imposed an image of a passive wife who will conform to the constraints laid upon them by patriarchal society (see chapter 8 regarding Mary). Whilst much of this

[143] Rosemary Radford Ruether, *Sexism and God Talk*, pp.40-60

[144] <http://search.proquest.com/docview/1855654799>

[145] Szymanski, 'Sexual objectification of women', p.39

has been challenged through the feminist movement, it is reinforced through Hollywood, especially through the medium of the Romcom – no matter how independent the female lead is, ultimately, she submits to the inevitable desire to find a man to complete who she is and to bring her comfort, protection and security. The Cinderella complex is alive and well in the western world.[146]

This whole notion of the objectification of women remains essentially androcentric. As objects of male desire, many women ultimately take up a passive role within society – they are seen as fulfilling male needs, rather than existing in their own right – and this has reinforced the inequality of men and women in senior roles within society. The role women play is that expected of them in order to fulfil the male fantasy.

The world of pornography reinforces these issues as women are subjected (whether willingly or unwillingly) to male domination, patriarchalism and brokenness. Whilst this world may provide an income and the appearance of power over men, it actually damages the prospects for all women of breaking out of this objectified role. It also reinforces the notion of sex without responsibility – a notion that the western world has bought into completely.

At the time of writing, the celebrity world is festooned with issues of sexual abuse and misconduct where those in power, such as movie moguls, have used their position to exploit women who are trying to take their formative steps in the industry. This is another product of the objectification of women, where such men cease to see a woman as a person and instead identify them merely as an object of their own personal satisfaction and fulfilment, to be discarded when finished with. The 'Me Too' campaign has been long

[146] See, for example, Pretty Woman

overdue but is an absolutely necessary part of challenging this mentality.

Many developments have a negative as well as a positive outworking. Breakthroughs in contraception over the last century have brought much positive benefit in releasing women from the home and enabling them to be able to pursue a career. This has lifted the spectre of drudgery for many entering family life with the inevitability of one child following another (my own great-grandmother had 22 children). However, on the negative side, it has broken the link between sexual intercourse and procreation. This has played into the hands of the male who is now free to 'play the field' without any responsibility. He can now pursue women as an object of his sexual desire without any need to consider them as persons, but simply as those who can bring him sexual fulfilment.

The tragedy is that women have bought into this fantasy. They, too, are expected to enter this world of 'free sex' not realising that the real winners in this are men who now have access to sex without responsibility and without even relationship (*Fifty Shades of Grey* is an example of this). That which was lauded as a victory in freeing women has, as a by-product, fuelled their subjugation in continued submission to men's objectification. Wendy Shalit has argued for a return to pre-sexual revolution standards of sexual morality as an antidote to sexual objectification.[147] Of course, some would argue that this works both ways and that men have also become subjugated as objects of female desire. Certainly, there is a sense of that in that the advertising industry presents the well-toned man as the image for men to aspire to, and young men are much more

[147] Wendy Shalit, *A return to modesty: discovering the lost virtue*, (New York: Touchstone, 2000) & Wendy Shalit, "Modesty revisited" in Orthodoxytoday.org. (2000) Fr. Johannes Jacobse

http://www.orthodoxytoday.org/articles/ShalitModesty.php [accessed: 06/03/2018]

body conscious. However, the focus of this chapter is on creating space for women to come into their God-given place in society and in the church, rather than being seen simply as objects of male desire.

I am not suggesting that we should do away with contraception here. I am simply saying that there are implications that have flowed out of its increased availability and use that were probably never considered when it was introduced in a wide-spread manner into society and which have dramatically changed the expectations of male-female relationships.

This has serious implications for young girls who are looking for acceptance and believe they will gain it from males by making themselves sexually attractive and this in turn reinforces their passage into the androcentric world of modern relationships. Janet Lee argues that young women are especially susceptible to objectification, as they are often taught that power, respect, and wealth can be derived from one's outward appearance.[148] There is a great need for us to engender the sense in those young girls we have responsibility for that identity, security, acceptance and self-worth need to flow from something deeper than fulfilment of male desire; rather, these things need to be rooted in our identity in Christ.

Before continuing it is important to clarify a few things: beauty is not a sin; showing ourselves physically in the best light is not a sin; desiring one another physically is not a sin. However, the context for all of this is within the framework of a committed relationship (i.e. marriage). That is the context within which both male and female sexual desire should be fulfilled.

[148] Janet Lee 'Menarche and the (hetero)sexualization of the female body' (September 1994) in *Gender & Society*, Sage. 8 (3): 343–362.

I, like Wendy Shalit, appeal to young women for modesty. That is no different from what the Apostle Paul does in 1 Timothy 2:9, against the backdrop of a lascivious culture. That does not mean wearing a puritanical black dress that buttons up to the neck, but rather dressing in a manner that does not put everything on display because this only feeds male desire and presents an impression of sexual availability. A number of radical feminists would argue that some modern women objectify themselves as an expression of their empowerment. Certainly, this seems to be the case with pop stars and movie stars. However, Ariel Levy suggests that Western women who exploit their sexuality by, for example, wearing revealing clothing and engaging in lewd behaviour, engage in female self-objectification, meaning they objectify themselves. While some women see such behaviour as a form of empowerment, Levy contends that it has led to greater emphasis on a physical criterion or sexualization for women's perceived self-worth, which Levy calls "raunch culture". Further, he argues that today's sexualized culture not only objectifies women, it encourages women to objectify themselves.[149] One of the things I love about travelling to India is the cultural-wide modesty. This is not the enforced modesty of the Muslim world (the bourka, etc.) but rather a modesty whereby women present themselves as beautiful without displaying their sexuality.

The problem with this objectified world is that the identity of many woman has become wrapped up in a male fantasy and that makes it very difficult for a woman to be accepted in her own right as a person with strengths, skills and with the capacity to lead men.

So, am I proposing arranged marriages so that marital relationships are taken out of the arena of simple sexual desire? Are such arrangements healthier than the lottery of

[149] Ariel Levy, *Female chauvinist pigs: women and the rise of raunch culture* (London: Pocket Books 2006)

boy-meets-girl, boy-desires-girl, boy-marries-girl? There are of course many ways we can consider this question, but it is worth for a moment lifting the lid on the whole notion of romantic love leading to marriage / commitment.

Prior to the Troubadours who travelled Western Europe in 11th-14th Centuries, marriages were almost universally an arrangement between two families. The troubadours popularised the notion of courtly love through the tales they included in their songs. The whole notion of courtly love was rooted in the knights who served a particular landowner trying to woo their master's beautiful wife (see especially the tales of Arthur, Guinevere and Lancelot). The notions of love and romance as the basis of relationship grew out of this and, over the following centuries, became the default position for much of Western Europe.

If we take a step back, the whole notion that a lifelong relationship should be built out of sexual desire and some deep feelings experienced associated with it has to be suspect. As a frequent watcher of First Dates, I am amazed how many people do not continue to pursue a relationship with a potential suitor because they 'didn't feel that spark'. Long term relationships are built, not on a 'spark', but on friendship, companionship, commitment and trust.

Am I dismissing love and romance? Certainly not! I could not have got through over 35 years of marriage without it, however, love and romance are not enough and are not a suitable or viable basis for a long-term relationship. We need to break out of a fairy tale (or Hollywood) notion of relationships and return to a more solid basis which is not founded purely on sexual desire or sexual compatibility, but rather is rooted in longer term values. For a biblical perspective on love and romance, see chapter 10 concerning The Song of Songs.

The problem with pre-marital sex is that it brings about feelings of pleasure and euphoria in a couple that can make them feel 'happy' and 'in love', but when life hits and the feelings pass, the relationship has no firm basis on which to rest and this is a contributing factor to break ups. If sex is deferred until marriage, it enables a courting couple to develop friendship and trust and find out if they are really 'compatible'. It is only then, out of real commitment, that sex becomes an expression of love rather than a substitute for it. It is only then that we can have a relationship of mutuality and respect based on more than libido.

Couples seeking a marriage partner need to spend time developing a relationship with one another and allowing that relationship to be tested. The best basis for a marriage is to marry your best friend. That does not mean someone who shares all your interests but it does mean someone you can share your most intimate thoughts, desires and pain with.

Objectification in the Church

In the previous chapter, I dealt with the deification of Mary. This has reinforced on the one hand the passive woman who is submitted to the male God, and on the other hand has allowed the Oedipus complex to exist without check. Just to clarify, Oedipus was a character in Greek Mythology who unknowingly married his own mother. Thus, in objectifying Mary as the object of male worship, there is a danger of men entering into a pseudo Oedipus complex.

The objectification of Mary has cast a long shadow that continues to have its effect in the Protestant nations of the world with the idealised passive notions of the pure virgin and the perfect mother. These have been reflected in the way women have been perceived of in the church. Those women who have had a voice in the last two thousand years, women

such as Hildegard of Bingen, Julian of Norwich, or Teresa of Avila, have all been nuns of one type or another and have therefore fulfilled the notion of the eternal virgin. Their writings have largely been associated with the revelatory gifts (seeing visions, etc.) rather than serious contributions to the development of theology (Perhaps Hildegard of Bingen could be seen to be an exception to this). Certainly, leadership outside of the convent has been inaccessible.

This has meant that leadership and theology within the church has been the domain of the male and the voice of women has not been heard. Instead, men have confined women to the home or the cloister and not allowed their ideas and thoughts to be listened to, or their experience to be understood or accepted as part of the gamut of Christian theology. I will return to the silencing of women by the church in the final chapter.

Sexual objectification

Finally, for any men reading this book, seeing a woman as an object dehumanizes her and disconnects her from ourselves personally. Once we dehumanize another person, we cease to feel guilt or take responsibility for the way we treat them.

Over the centuries, it is the dehumanizing of individuals that has enabled humanity to do such unspeakable things to one another. And yet, we persist in dehumanizing women by objectifying them. This is the basis of the sex industry, and especially pornography.

A person on a screen is not a real person. Thus, I can think what I like about them and watch them doing whatever brings personal gratification without ever thinking about them as an individual. However, behind that screen is a real

person with a soul and a spirit, who is an object of the love of God. They have feelings and emotions and real issues and hurts. Who knows why they have found themselves in that industry?

We need to rid our society of the scourge of pornography, not simply because it opens us up to temptation, but because it contributes to maintaining women as objects which adds to their subjugation. This is not an issue of morality as much as of justice. Every time we click on an inappropriate link, we contribute towards maintaining the patriarchal status quo. As Christians, and as members of the church of Jesus Christ, we need to make a difference in this area.

Conclusion

Whilst desire for one another as men and women is real and natural, emphasis on it has skewed our perceptions of one another and contributed to the patriarchalism and androcentrism which has kept women subjugated. We need a new understanding of what makes a solid foundation for relationships in the home, in the workplace, in society, and in the church. This should be based on the notion of equality and mutuality, not on the basis of objectification and desire.

Richard Bradbury

Chapter 10

The Song of Songs – an ideal relationship

Introduction

The Song of Songs is one of the most beautiful pieces of poetry I have ever read and yet, it is only as I have come to study it that I have begun truly to understand it, both in terms of its imagery and its purpose. I have always been taught that it is a metaphor of the love between Christ and the Church. Whether or not that is a valid inference, I have come to see it far more as a picture of God's intention between a man and a woman. In the remainder of this chapter I will seek to explore this notion after first considering the background and the various interpretations that have been applied to the book.

Of course, the focus of this book is not the marriage relationship but rather the emancipation of women in the New Churches to their God-given role. However, as we see the dynamics and outworking of the idealised marriage relationship in this book, and the way it portrays a relationship restored to pre-fall equality, so we can grasp something of the appropriateness of the restoration of the same in the church.

Background

The traditional author of this book, Solomon, cannot be affirmed with any certainty, although scripture does attribute songs and psalms to Solomon (Pss 72 and 127) and

1 Kings 4:32 identifies Solomon as the author of '1005' songs, of which this may be one. Within the Song itself there are numerous references to Solomon and SoS 6:8 would seem to place it early in his reign before he had assembled the famed 'seven hundred wives... and three hundred concubines' (1 Kings 11:3). As Estes says, 'the book seems to reflect a setting in a unified and prosperous Israel, which would fit well with the glorious reign of Solomon'.[150] So whilst we cannot affirm with certainty the author of the Song of Songs, there is some internal evidence to place it within Solomon's reign in the early Tenth Century BCE, however, as Estes points out, other scholars have positioned it as a much later work which looks back to 'the time of Solomon as a legendary golden age'.[151] Also, the fact that so much of the book is written in the first person from the perspective of the Shulammite woman might suggest a female author. If the author was female, this is unprecedented in terms of the Bible. As Estes concludes, 'no one as yet has argued convincingly enough to produce a consensus about who wrote Song of Songs, and when.'[152]

The book is structured as a number of songs which relate to the theme of love – exactly how many songs is also an issue of debate amongst scholars. The continuity of language, characters, images and theme throughout the songs would suggest a single composition, however, some have argued that it is a collection written by different authors over a period of time. From my knowledge and experience of poetic reading the argument for the poem's unity of author is stronger than that for its diversity.

[150] Daniel J. Estes, *Handbook on the Wisdom Books and Psalms* (Grand Rapids: Baker Academic: 2005), p.393

[151] Ibid., p.394

[152] Ibid. P.395

Interpretation

Carr identifies four major methods of interpretation of the Song of Songs: allegorical, typological, dramatic (including cultic) and natural.[153] Estes presents a detailed summary of the interpretations that have been given to this book.[154]

The first mode of interpretation, the allegorical, as applied by both Jewish and Christian scholars, sees the book as entirely figurative and spiritual, relating either to the relationship between Yahweh and Israel or of Christ and the Church. As Estes affirms, 'there is no objective means of validating the accuracy of an allegory so this approach leads to numerous disparate interpretations that are limited only by the imaginations of the commentators'.[155] Also, 'the allegorical approach allows for a complete bypassing of the erotic passages' which are self-evident and therefore does not do justice to the text.[156]

The second approach, the typological interpretation, accepts the historicity of the scripture, but then identifies parallels with New Testament teaching. However, the issue in moving from the literal and historical to the typological interpretation is that it is open to the subjectivism of the allegorical approach.

In the third approach, the dramatic interpretation identified by Delitszch among others, a plot is read into the book involving two or three characters (Shulammite, shepherd lover and Solomon), a young woman who is 'pursued by Solomon' but who, at the end, 'rejects the king and embraces her true love'.[157] Personally, I do not find this approach convincing, primarily because I do not see the three

[153] G. Lloyd Carr, *Tyndale Old Testament Commentaries: The Song of Solomon* (Leicester: Inter-varsity Press, 1984), pp.21-36

[154] Estes, *Handbook on the Wisdom Books and Psalms,* pp.396-401

[155] Ibid., p.398

[156] Arnold G. Fruchtenbaum, *Biblical Lovemaking: A study of the Song of Solomon* (Tustin: Ariel Ministries Press, 1983), p.2

[157] Estes *Handbook on the Wisdom Books and Psalms,* p.399

characters suggested in the text, but only two. In addition, the lack of dramatic instruction and the dearth of comparative dramatic literature amongst ancient Semitic peoples would lead the interpreter towards speculation in this regard. The text does not naturally form a sequence of events or plot and therefore any attempt to read this into the text has to be provisional at best. The Song is rather 'a unified collection of love poetry, designed to trace and develop themes but not to advance a particular plot'.[158]

This brings us to the natural interpretation of the text as a 'celebration of human love'. As Richard Hess expresses it, 'the Song is not a drama or a sequential narrative. It is not an allegory. It is not an anthology of diverse erotic poetry. The song represents a poetic unity, expressing in its pages a most sublime love poetry'.[159] For myself, I find this the most convincing interpretation and will focus my reflections throughout the remainder of this chapter from this perspective.

Reflection

'Song of Songs, in a manner evidenced only infrequently in the Biblical text, extols the richness of human erotic love as a gift from God'.[160] In contrast, over the centuries, much Christian literature has condemned erotic love as sinful. As Augustine put it, 'conjugal chastity makes a good use of the evil of concupiscence in the procreation of children'.[161] Song

[158] Richard S. Hess *Baker Commentary on the Old Testament Wisdom and Psalms: Song of Songs*, ed. by Tremper Longman III (Grand Rapids: Baker Academic, 2005), p.27

[159] Hess *Song of Songs*, p.34

[160] Estes, *Handbook on the Wisdom Books and Psalms*, p. 401

[161] Augustine *On Marriage and Concupiscence* Source: Translated by Peter Holmes and Robert Ernest Wallis, and revised by Benjamin B. Warfield. From Nicene and Post-Nicene Fathers, First Series, Vol. 5 Edited by Philip Schaff (Buffalo, NY: Christian Literature Publishing Co., 1887) Revised and edited for New Advent by Kevin Knight., http://www,newadvent.org/fathers/1507.htm> [accessed 07/06/2011].

of Songs, on the other hand, is a celebration of romantic and erotic love between a man and a woman incorporating courtship, marriage and sex, including sexual adjustment after marriage. Fruchtenbaum suggests that 'these are real historical situations through which God intends to teach lessons regarding the divine viewpoint in these very areas'.[162] Whether or not the details are real historical events, the appearance of these poems as part of the wisdom literature of the Bible does suggest that there is a requirement for a positive image of erotic love within the context of marriage. Thus, there is a didactic purpose in the inclusion of this book in the canon of scripture and the subject couple act as a model for understanding love, passion, sex, commitment, and sensitivity within a marriage relationship.

Hess points out, 'within the biblical context this positive theme of physical love contrasts strongly with the persistent negative statements on adultery, promiscuity, and the images of Israel as an unfaithful wife as found in the prophets'.[163] This of course presupposes that the couple in Song of Songs are married and, given the context in which this book occurs within scripture, and the use of the term 'bride' for example in SoS 4:8, this would seem to be a valid inference, although, as Hess points out, 'for the Israelites who first read it, as for Bible readers of later periods, it may presume a sexual relationship within marriage. However, this is never made explicit'.[164] Thus, the message that physical love in all its forms is valid and beautiful within marriage contrasts strongly with the images of the violated marriage bed both in the Law and in the prophets.

Hess goes on to say that Song of Songs 'also provides a counterpoint to the institutionalized patriarchalism of much

[162] Fruchtenbaum, *Biblical Lovemaking*, p.2

[163] Hess, *Song of Songs*, p.33

[164] Ibid., p.35

of Israelite society by giving the female lover the dominant voice in the dialogue'.[165] Brenner identifies this poem, with its 'female perspectives or even authorship' as that which has given 'the opportunities for discussing female culture' from a biblical perspective.[166] The presentation of the two lovers on an apparently equal footing contrasts with the male dominated cultural representation of marriage within scripture as a whole and gives a window into a different world of male and female relationships and sexuality. As Huwiler suggests, 'the song presents a view of male-female sexuality which is neither exploitative or hierarchic. Both the man and the woman act on their own initiative as well as in response to one another. Neither is controlled by family or social interests'.[167]

Schwab picks up on some negative themes that can be drawn from this book, commencing with his identification of the thrice used phrase 'do not arouse or awaken love until it so desires' (SoS 2:7, 3:5, 8:4), which he argues 'should be understood as warnings concerning the power of love'.[168] He also discusses the comparison in the Song of Songs of love and death (8:6), the negative effects of lovesickness, and the power of love to diminish and control lovers, and thus identifies 'the negative component of the Song's message to lovers'.[169] For me, he overstates the case for the negativity of this message which, while present, merely exacerbates the passion and beauty of the relationship of the lovers. The emotions Schwab identifies are an integral part of being

[165] Ibid., p.33

[166] Athalya Brenner, *A Feminist Companion to The Song of Songs*, Ed. by Athalya Brenner (Sheffield: Sheffield Academic Press, 1993), p.28

[167] R. Murphy and E. Huwiler *New International Biblical Commentary: Proverbs, Ecclesiastes, Song of Songs* (Peabody, MA: Hendrickson Publishers Inc., 1999), p.242

[168] George M. Schwab *The Song of Songs' Cautionary Message Concerning Human Love* (New York: Peter Lang Publishing Inc., 2002), p.1

[169] Ibid., p.2

passionately in love, but, where that love is reciprocated, they add to the joy and satisfaction of that relationship. Schwab suggests there is a 'curious lack of "satisfaction" in the song', but I do not accept this position and rather see love and erotic anticipation satisfied in full, particularly in verses such as 5:1.[170] However, the warning not to 'arouse love' until there is an opportunity for it to be satisfied is valid for both courting and married couples, where such can lead to frustration and, in the former case, can provide the fuel for premarital sex, and in the latter, for relational conflict. Whilst Schwab identifies and discusses some important themes, I believe these are subsidiary to the positive image of love and sex promoted in this book.

This leads us to the apparent rejection of sexual advances by the Shulammite Woman (dreamed or otherwise) in SoS 5:2-8 which Estes and others identify as 'the subversive effect of selfishness within a marriage relationship'.[171] The Shulammite at first rejects her lover but then relents but when she goes to find him he is gone. She searches for him and experiences pain (real or figurative) but, in the end, finds him and is reunited with him. This whole incident is an instruction to couples in the first throws of passion that some adjustment, accommodation and sensitivity may be required in order to facilitate one another's needs within marriage.

Landy argues that the Song of Songs 'constitutes an inversion of the Genesis narrative...The Genesis myth points outside the garden; the Song goes back to it.'[172] The garden motif is strong throughout Song of Songs and perhaps, as Landy suggests, leads us to compare the two gardens and see that the connection experienced by the couple in this poem leads us back to the original intention for humanity of

[170] Ibid., p.2

[171] Estes *Handbook on the Wisdom Books and Psalms*, p.422

[172] Francis Landy, 'Two Versions of Paradise' in *A Feminist Companion to The Song of Songs*, Ed. by Athalya Brenner (Sheffield: Sheffield Academic Press, 1993), p.129

perfect companionship that was marred at the Fall. The consequence of the curse for the woman, 'Yet your desire will be for your husband' (Genesis 3:16), is perhaps reversed in this poem as we hear her say, 'I am my beloved's and his desire is for me' (SoS 7:10). Thus, the original intent for man and woman to be a companion and helpmeet for one another can be restored where true love, within a monogamous relationship is experienced. Perhaps this foreshadows the final garden of Revelation 22 where we see the full restoration of creation and the reinstatement of the tree of life; where 'there will no longer be any curse' (Revelation 22:3). As such, the marriage relationship, when not selfish and destructive, is the closest we can come to that future city of God this side of the grave.

Conclusion

Within this chapter we have considered the Song of Songs as a poem relating scenes of an idealised (though not perfect) relationship between a man and a woman. I believe it is included within the canon of scripture as a celebration of this relationship and to give instruction for young lovers in finding their way in the early throws of love and passion. As Carr puts it, 'The Song is a celebration of the nature of humanity – male and female created in God's image for mutual support and enjoyment'.[173] Whilst being aware of other approaches to this book I believe such interpretations are secondary to the above.

Having stated all of the above, perhaps it is incumbent on me to make a few comments on how this contrasts with the image of love, marriage and sex in modern society. Some of this I have alluded to in the previous chapter, however, there is more to be said concerning the way all of these things are

[173] Carr *The Song of Solomon*, p.54

portrayed in the media, on television, in film and in society generally.

Picking up on the *Fifty Shades* franchise once more for a moment, what is portrayed in the book is the antipathy of the relationship portrayed in the Song of Songs. In the story, a man and a woman enter into a contract for sex without relationship, where physical pleasure becomes an end in itself instead of the fruit of mutual commitment, and where dominance and submission is the form of the 'relationship' rather than one of love, acceptance, and mutual support. Presenting characters who are in regular roles within society, Christian is a businessman, and Anastasia is a student, normalises BSDM[174] and makes it acceptable, even though it leaves Anastasia confused and devastated.

This kind of portrayal of sex, where dominance and submission are regularised, undermines both men and women in setting them up with expectations that will leave them with damaged souls. Such a 'relationship' is in complete contrast with the one we find in the Song of Solomon, and yet, Hollywood portrays this as a relational form that is perfectly acceptable in modern society. Further, Hollywood sensationalises sex. At the time of writing, there has been some controversy over the Jennifer Lawrence movie *Red Sparrow* which has been described as 'sexploitation'. 'The treatment of Lawrence in the spy thriller is sadistic and voyeuristic. The director goes out of his way to make her suffer, treating her with a callousness that rekindles memories of Hitchcock's behaviour with his 'blondes'.[175]

Such normalisation of sex and violence cannot help but stimulate negative and aggressive expectations in our

[174] Bondage/Discipline, Dominance/Submission, Sadism/Masochism

[175] Geoffrey Macnab, *The Independent* (07/03/2018) < http://www.independent.co.uk/voices/jennifer-lawrence-red-sparrow-review-actor-film-decisions-cold-war-spy-thriller-a8244391.html> [accessed: 08/03/2018]

society. The link between violence portrayed on film and actual violence is well documented,[176] as is the effect of BSDM on young men who seek to replicate such behaviours with those they have sex with.[177]

On the one hand, Hollywood presents us with a diet of unhelpful relationship images and on the other hand stands hypocritically condemning such relationships when they are worked out in real life. I am not trying to justify the Weinsteins of this world here, but all who take part in the presentation of these kind of relationships are complicit in the way such things then become part of the culture.

The Bible, and specifically, the Song of Solomon, presents us with a very different model of love, sex and relationships which should inform our own way of being together as men and women in marriage as we seek to get back to the divine intention. Whilst the likes of Augustine did a lot of damage in making sex, even within marriage, a source of shame for both men and women, the Word of God takes all shame away from this expression of love. God wants to take us back to the Garden '(they were naked and were not ashamed' (Genesis 2:25)) so that we can enjoy the fruits of our relationship in full without embarrassment or shame, and in the context of fellowship with one another and with our Father.

[176] For example, 'Violence in the Media' on *American Psychology Association* <

http://www.apa.org/action/resources/research-in-action/protect.aspx> [accessed: 08/03/2018]

[177] For example, Gert Martin Hald, Neil M. Malamuth, Carlin Yuen, 'Pornography and attitudes supporting violence against women: revisiting the relationship in nonexperimental studies' on Wiley Online Library,

<http://onlinelibrary.wiley.com/doi/10.1002/ab.20328/full>, [accessed 08/03/2018]

Chapter 11

Conclusion

Introduction

In this book we have considered many aspects of the role of women in the church. We began by considering the feminist perspective and how this has challenged the cultural norms of patriarchy and androcentric thinking. From here we considered how gender is actually determined and the implications of this for leadership roles. Next, we sought the Biblical view on male and female functions. This led to a consideration of women in the Bible. We highlighted two women in particular: Mary and Jezebel, and we considered the way these two women have influenced male thinking and attitudes in the church. From this we looked at the objectification of women in society generally. Finally, we considered the Biblical picture of an idealised (although not perfect) wife/husband relationship as portrayed in the Song of Songs.

Historically, men and women have been forced into certain roles within society as a result of cultural and physiological expectations and limitations. Scientific and sociological progress has changed such expectations such that women are no longer tied to the home fulfilling certain domestic chores. Labour saving devices have taken the drudgery out of many of these tasks. Contraception has removed much of the inevitability of 'get married, have children'. Feminism has challenged the glass ceiling such that women can now aspire to top roles within the corporate and political world,

as well as in the public sector (there is still work to be done in this area particularly around the pay gap).

The Evangelical world has been one of the few bastions of male domination. For the most part I believe this has been primarily a theological barrier. Male leadership has assumed an understanding of scripture that is conservative and literal, and which has assumed that leadership is male. Sometimes such understandings need to be challenged in order to be thought through at a deeper level. This does not mean we adopt our theology along the lines of social trends. Rather, that we allow the voice of society to challenge us to think so that we evaluate honestly our long-held positions. It may be that we return to those same positions, however, we do so from the perspective of having a deeper understanding of why we believe such things.

In this book I have sought to challenge those of us who exist in the New Church world to do just that – think through our position with regard to the role of women at a deeper level. In this last chapter I would like to make suggestions as to how relationships between men and women might function in the church and in the home.

The Silencing of women in the Church

Before I draw this book to its conclusion, it is worth mapping out how women came to be excluded from ministry within the church, and therefore what needs to be done to address it. As we have seen, during the early centuries, women played a full role within the ministry of the church. This continued to the end of the Patristic period. In fact, so many women were influential in the affairs of the church that the Pagan philosopher, Porphyry, who wrote *Against the Christians* around 300AD, which consisted of fifteen books, complained that Christianity had suffered as a result.

However, by the end of the Patristic period, the hierarchy of the church was exclusively male. In fact, from fairly early on in the Patristic period, the sacraments were carried out only by men. The quote from Tertullian (c. 155-240 AD) in chapter 3 above shows how the thinking of the church fathers was beginning to be shaped to exclude women from ministry. Origen also wrote similarly regarding silencing women in church.

From the end of the Patristic period onwards, in both East and West, the ministry of women was largely restricted to the hermit communities of the deserts or to the monastic convents. The First Council of Orange in 441AD formerly forbade the ordination of women to the diaconate.[178] From this time through to the Renaissance, whilst a few women did make contributions to Christian thought (see the list in Chapter 9 above), and one, Joan of Arc, even led the army of France in response to a vision, for the most part women were allowed no office or voice in the wider church. This was despite the fact that a number held significant political power and influence during this time (we could mention Matilda, Eleanor of Aquitaine, Isabella of France and Margaret of Anjou, although it is interesting that these women have all been labelled 'she-wolves' by historian Helen Castor[179]).

The Reformation brought with it the closing of both convents and monasteries. This meant that the one clear avenue of spirituality and theological thought became closed to women. Martin Luther taught that "the wife should stay at home and look after the affairs of the household as one who has been deprived of the ability of administering those affairs that are outside and concern the state...."[180] John Calvin also said that "the woman's place is in the home."[181]

[178] William Weinrich, "Women in the History of the Church", in John Piper and Wayne Grudem (eds.), *Recovering Biblical Manhood and Womanhood*, (Crossway: 1991)

[179] Helen Castor, *She Wolves: the women who ruled England before Elizabeth*

[180] Martin Luther, *Lectures on Genesis* 3:11.

[181] Calvin, John. "A Sermon of M. Iohn Caluine upon *the Epistle of Saint Paul, to Titus.*"

The majority of Protestant churches have upheld this position up until the twentieth century, with one or two exceptions. The Quakers allowed women to participate in their meetings from the beginning (1652). John Wesley allowed women to speak if they "are under an extraordinary impulse of the Spirit"[182]

In Britain, the Baptist Church ordained women into ministry from the 1920s. The Church of Scotland allowed women to become deacons from 1935, to preach from 1949, and to be ordained as elders in the church from 1966, with full ministerial responsibility from 1968. The Free Methodist Church has ordained women since 1911. The Anglican Church has allowed the ordination of women deacons since 1985, women priests since 1992, and women bishops since 2014.

In the protestant church, one of the last bastions to hold out against allowing women full access to leadership and ministry is the Evangelical church. As discussed above, this is for apparently good theological reasons but, as we have seen, when we take a closer examination of the scriptures, these reasons are not as clear cut as has been suggested. The argument of this whole book thus far is that it is time for a change. One of the key visions of the New Churches is to re-establish the church as it was in the early years and one of the elements of this is the full restoration of women to the role they occupied in those early heady days – the role affirmed by Jesus, Paul et al. So, how can this be achieved?

Taking off the shackles

In all that has preceded this chapter, I have been at pains to express the idea that women and men are equal and that

[182] John Wesley's notes on the Bible, 1 Cor. 14:34,35

both can perform in any role within the church. Further, the New Testament contains good evidence for women holding the position of prophet, deacon, and even apostle, as detailed above. It is time to unlock the doors that have kept women from performing these functions.

In our younger days, we were in a Brethren church, which restricted women from having any voice at all in the meetings. After a number of discussions, beginning with the elders, and then with the deacons, and finally with the wider church, we explored opening up the meetings to female input. Whilst this may not be considered radical now, at the time it was revolutionary for that church. I remember the first Sunday after the decision had been taken sitting in the communion service waiting to see if any woman would speak. I think some thought that, if one did, there would be an earthquake. In the weeks and months that followed some did find their voice and it became normalised for them to participate.

In this episode, there are a number of indicators as to how we can address this whole area. The first is through dialogue. Most people do not like things to be imposed upon them, but if they can participate in the process, they are more likely to agree, even if they maintain some reservations. A church wanting to open up its ministry to men and women alike needs to engage in dialogue with the members, not necessarily to reach consensus – agreement may still not be reached with all – but to ensure that everyone is listened to. Then, the leadership can begin to move things forward.

Secondly, affirming women and their gifting is one step towards enabling them to function within it. If a leader affirms the women in their congregation, this will create a positive atmosphere which will encourage others to appreciate and affirm them. This will then open the way for further ministry opportunities.

Thirdly, a leader needs to open the door for women. This means positive action in giving them opportunities to speak, lead, do communion, baptise and to participate in every way in the full life of the church. Last year, at a question and answer session at the women's retreat run by our church, I was asked my opinion on allowing women into leadership in the church. I explained my position (as per this book). I was then asked when I was going to allow women to minister. In reply, I reminded the questioner that, in our church, women operate as deacons, lead the meetings, preach, lead worship, do outreach, and have a full role in both the Senior leadership team and the wider leadership team of the church. The only role in which a woman has not yet functioned in our church is mine, and I am not quite ready to retire yet. At that point, a light went on for the person asking the question, who recognised that, whilst we have not made a big thing of it, women are fully functional within our church.

Feminisation / Masculinisation

I do have a word of caution, however. In opening up these positions, I would be loath to see a greater feminisation of the church. What do I mean by this? The church has become a place where people (men in particular) who have more traditionally masculine characteristics (whether socially conditioned or naturally arising) have become increasingly alienated. I am not talking here about putting on testosterone loaded events so that men can feel at home. Rather, the church should be a place where the full gamut of human characteristics are demonstrated in worship, in discipleship and in mission. This feminisation is more as a result of the absence of men who have walked away from the church than they are of the activities of women who have been the mainstays of the church over the last two centuries.

Calum Brown argues that the decline in church attendance over the last 200 years was a rejection of 'the dominance of a Christian culture within British Society' which was repressive and which kept piety as feminised. This discourse alienated men and kept women in their place in the home ('the female discourse of domesticity was ideologically affirmed primarily by Christianity') as the custodians of a Christian piety.[183] It was this piety that maintained the Christian culture and when it waned, the door was opened for secularisation. When women ceased to be the means through which the family was kept 'Christianised', secularisation of the whole of society followed and Christendom in Britain collapsed.

Brown's argument is based on the notion that second wave feminism liberated women from the constraints of Christianity. 'British women secularised the construction of their identity and the churches started to lose them' at the beginning of the 1960s.[184] He argues that the church had already been losing men for the previous 150 years as piety had become feminised. He suggests that 'as well as feminising piety, evangelicalism pietised femininity'.[185] Thus, in the traditional denominations, whilst leadership remained essentially male, worship and preaching took on a form that embraced female piety and alienated masculinity.

Without rehearsing all his arguments here, and without necessarily agreeing with them (see especially Hugh McLeod's response to Brown[186]), I believe his suggestion that the church and piety became feminised has some credibility. How true this is for the New Churches is a separate

[183] Calum Brown, *The Death of Christian Britain: understanding secularisation 1800-2000*, Second edition (Oxford: Routledge, 2009) p.200

[184] Ibid., p.192

[185] Ibid., p.59

[186] Hugh Mcleod, *The Religious Crisis of the 1960s* (Oxford: Oxford University Press, 2007)

question, however, all this leads me to the conclusion that, in opening up all roles to women, we do need to retain the characteristics of masculinity and femininity within our worship and culture such that both men and women are embraced within it.

The risk in saying this is that I am embracing the binary differences between men and women which I have discarded in chapter 2 above. In order to avoid this, I need to give some clarification here. The list of binary characteristics which were identified are a range of characteristics that exist across humanity both male and female. In identifying one set exclusively with men and one set exclusively with women we create a caricature. The reality is, as I pointed out, that most of us have a selection of these characteristics from both lists regardless of our gender.

What has happened over the centuries is that women have been encouraged to conform to and exhibit those characteristics, such as nurturing, spiritual intuition and open emotions, regarded as 'feminine', and have been discouraged or even opposed when they have exhibited those associated with 'masculinity', characteristics such as power, courage and risk taking. The result has been a church that is high on feelings and emotions, pastoral care and the prophetic, but reluctant to step beyond its walls.

The church is a place that needs to make room for all men and women – a place where both can feel comfortable to express themselves without feeling judged or put down. A place where all can find their God-given role and function within it. A place where Galatians 3:28 is seen to be true.

It is time to see the full redemption of all that it means to be 'made in God's image', expressed through women and men together who are free to be all that they are out of their identity in Christ. We need to create an environment that

makes room for the adventurer as well as the poet; where the prophetic is seen alongside the apostolic; where reflection and action are seen in harmony with each other; and where pastoral care is not just 'nannying' but also contains the stimulus to make changes and see transformation.

In the Home

The advances in technology and in our understanding of anthropology have brought us to the place where, in society, we are willing to embrace difference of all sorts. If we lay aside the principle of male headship, how can we function in the home with integrity as Christians?

I believe the secret is in an honest appraisal of our strengths and weaknesses as couples. If I am better qualified or with a greater aptitude to look after the finances than my wife, it is sensible if I do just that. If she is more able at strategic planning than me, it is sensible that she looks ahead to where we want to go as a family in all aspects and formulates some plans which then can be agreed by both of us.

Scripture does not argue for domination in the New Covenant, but mutual submission. If we each aim to work not to please ourselves but our partner, for the good of the household, rather than defending our rights, the household will become a place of love, commitment, hospitality and joy. If we spend all our time fighting over money, sex and power, the relationship and the household will be torn apart.

Paul's argument in Ephesians 5 is that men should love their wives sacrificially, and that women should respect their husbands. Both of these actions require giving not taking. Both of them contribute to creating a household where Jesus is at the centre.

Celibacy

One area we have not touched on at all is the role of the celibate, whether male or female. I believe that God can use us in whatever situation we find ourselves; so celibacy should not be a limiting factor to the full functioning of God's child within the church or in the home.

This area could, of course, be the subject of a book in its own right and so I do not intend to explore this further here.

Conclusion

In this book I have laid out a clear egalitarian position concerning the role of women in the church. In order to come to this position, I have revisited scripture, particularly the difficult passages. I have taken into consideration the views of feminist theologians as well as more conservative theologians. I have considered the question of gender and whether that in itself prohibits men or women from certain activities, particularly leadership, and concluded that it should not be a limiting factor. I have also considered the women of the Bible and how they broke the mould in order to fulfil their calling. From here I have examined the negative impact of the widespread objectification of women and how the Song of Solomon can lead us back to the divine intention of mutual respect and honour in our intersexual relationships.

My plea is that, as we go forward as the New Churches, we might re-examine the scriptures. This was certainly my starting point as I was challenged to think about these issues. As I said in the introduction, I had to resolve the issue theologically before I could resolve it practically. That meant listening to voices that I would not normally have listened to, voices of women who were writing out of their

frustration and pain. This brought me to a whole new perspective on these issues.

I long to see a church where women and men take their place alongside each other to lead truly in the image of God. I want it to be a place where my daughters as well as my sons are allowed to employ their God-given gifting without prejudice or limitation. I want to see the Body of Christ as a full blown mature man (Ephesians 4:13), and as the Bride of Christ (Revelation 19:7). I don't think my dream is unattainable, but it does require us to make some shifts in our thinking followed by some positive action so that the equality, mutuality, respect and gifting can thrive and where all who come amongst us can rise up to take their God-ordained place in the Body of Christ.

Whether or not you agree with the position I have taken in this book, I hope you have found it an interesting and challenging read. These things do not affect the essentials of the faith and therefore should be open to proper debate. We do not need to take sides or fall out about these things since they shape our praxis rather than our belief. Grace and a non-judgmental spirit are required in any such exploration.

As we have seen above, there is substantial evidence of women in leadership roles in both the Old and New Testaments. Whatever our conclusions concerning the role of women in leadership we must take account of the biblical record in this respect.

Galatians 3:28 makes it clear that under the new covenant inaugurated by Jesus Christ, all the OT restrictions of race (Jew and Greek), social status (slave or free), gender (male or female) have been removed. That should be a principle that governs the culture of the Church going forward.

Bibliography

1. Abbot, P., C. Wallace & M. Tyler, *An introduction to sociology: feminist perspectives* (3rd Edition), (London: Routledge, 2005), chapter 2: 'Feminist sociological theory', pp.16-56

2. Mowczko, Marg, *Is God Male or Masculine?* <http://newlife.id.au/equality-and-gender-issues/is-god-male-or-masculine/_> [accessed: 06/03/2018]

3. Author unknown, *Didache* Tr. By J.B Lightfoot <http://www.earlychristianwritings.com/text/didache-lightfoot.html> accessed [07/12/2017]

4. Author unknown, 'Jezebel (1938)' from IMDB <http://www.imdb.com/title/tt0030287/> [Accessed: 06/12/2017]

5. Author Unknown 'Violence in the Media' on *American Psychology Association* < http://www.apa.org/action/resources/research-in-action/protect.aspx> [accessed: 08/03/2018]

6. Author unknown, *Women in ancient Israel, Jewish Women and the temple*, <http://www.bible-history.com/court-of-women/women.html> [accessed: 06/03/2018]

7. Augustine *On Marriage and Concupiscence* Source: Translated by Peter Holmes and Robert Ernest Wallis, and revised by Benjamin B. Warfield. From Nicene and Post-Nicene Fathers, First Series, Vol. 5 Edited by Philip Schaff (Buffalo, NY: Christian Literature Publishing Co., 1887) Revised and edited for New Advent by Kevin Knight., <http://www,newadvent.org/fathers/1507.htm> [accessed 07/06/2011].

8. Mowczko, Marg, *The Twelve apostles were all male*,< http://newlife.id.au/equality-and-gender-issues/the-twelve-apostles-were-all-male/> [accessed: 06/03/2018]

9. Belleville L. L, Blomberg C, Keener C. S, Schreiner T. R, *Two Views on Women in Ministry*, (Zondervan: Michigan, 2009), kindle ed.

10. Benger, Paul,
 <https://paulbenger.net/2016/09/04/theology-who-killed-junia/> [accessed: 06/03/2018]

11. Borresen, Kari Elisabeth, 'Women's studies of the Christian Tradition' in *Religion & Gender*, ed. by Ursula King (Oxford: Blackwell Publishers, 1995), pp.245-255

12. Bouma, Rolf, 'Feminist Theology: Rosemanry Radford / Sallie McFague', *Boston Collaborative Encyclopaedia of Western Theology: Feminist Theology 1997*, http://people.bu.edu/wwildman/bce/mwt_themes_907_re uthermcfague.htm , [accessed: 02/02/2012]

13. Brenner, Athalya, *A Feminist Companion to The Song of Songs*, (Sheffield: Sheffield Academic Press, 1993)

14. Brown, Calum, *The Death of Christian Britain: understanding secularisation 1800-2000*, Second edition (Oxford: Routledge, 2009

15. Burrowes, George, *The Song of Solomon* (Carlisle, Penn: The Banner of Truth Trust, 1853, reprinted 1977)

16. Calvin, John. "A Sermon of M. Iohn Caluine upon *the Epistle of Saint Paul, to Titus.*"

17. Carr, G. Lloyd, *Tyndale Old Testament Commentaries: The Song of Solomon* (Leicester: Inter-varsity Press, 1984)

18. Daly M, *Beyond God the Father: Towards a Philosophy of Women's Liberation*, (The Woman's Press Limited: London, 1986), 3rd edition

19. D'Angelo, Mary Rose, 'Veils, Virgins, and the Tongues of Men and Angels: Women's Heads in Early Christianity, in *Women, Gender, Religion: a reader*, ed. by Elizabeth A. Castelli with assistance from Rosamond C. Rodman (Houndmills, Basingstoke, St. Martin's Press, 2001), pp.389-419

20. Dunn, James D.G., *The Theology of Paul the Apostle* (London: T&T Clark Ltd, 1998)

21. Durham, James, *The Song of Solomon* (Edinburgh: The Banner of Truth Trust, 1840, reprinted 1982)

22. Ellsworth, Roger *He is Altogether Lovely: Discovering Christ in the Song of Solomon* (Faverdale: Evangelical Press, 1998)

23. Estes, Daniel J., *Handbook on the Wisdom Books and Psalms* (Grand Rapids: Baker Academic, 2005)

24. Evans M, *Woman in the Bible*, (paternoster press: Cumbria, 1998), second edition

25. Fiorenza, E.S., *In Memory of Her: a feminist theological reconstruction of Christian origins*, (2nd Ed.), (London: SCM Press, 1995)

26. Fiorenza, Elizabeth Schussler, 'Rhetorical Situation and Historical Reconstruction in 1 Corinthians' in *Christianity at Corinth: The Quest for the Pauline Church*, eds. David G. Horrell and Edward Adams (Louisville: WJKP, 2004) pp.146-160

27. Forster F & R, *Women and the Kingdom*, (PUSH publishing: 2014), kindle ed.

28. Fruchtenbaum, Arnold G., *Biblical Lovemaking: A study of the Song of Solomon* (Tustin: Ariel Ministries Press, 1983)

29. Gaines, Janet Howe, 'How Bad was Jezebel' in *Bible History Daily* <https://www.biblicalarchaeology.org/daily/people-cultures-in-the-bible/people-in-the-bible/how-bad-was-jezebel/ > [Accessed: 06/12/2017]

30. Glifillan Upton, B., 'Feminist theology as biblical hermeneutics', in *The Cambridge Companion to Feminist Theology*, ed. by S. Frank Parsons, (Cambridge University Press, 2002), pp.97-113

31. Goldbenberg, Naomi, 'The return of the Goddess', in *Religion& Gender*, ed. by Ursula King (Oxford: Blackwell Publishers, 1995)

32. Graham, E., *Making the difference: gender, personhood and theology* (London: Mowbray, 1995)

33. Grudem W, *Evangelical Feminism: A new path to Liberalism?* (Crossway Books: Illinois, 2006, kindle ed.

34. Guyon, Madame, *The Song of Songs* (Augusta: Christian Books, 1983)

35. Hammack D, *Working with Oneness: New Metaphors for God*, <http://www.doughammack.com/working-with-oneness-new-metaphors-for-god/>

36. Hald, Gert Martin, Neil M. Malamuth, Carlin Yuen, 'Pornography and attitudes supporting violence against women: revisiting the relationship in nonexperimental studies' on Wiley Online Library, <http://onlinelibrary.wiley.com/doi/10.1002/ab.20328/full >, [accessed 08/03/2018]

37. Haraway, Donna J., '"Gender" for a Marxist Dictionary: The Sexual Politics of a Word', in *Women, Gender, Religion: a reader,* eds. Elizabeth A. Castelli with assistance from Rosamond C. Rodman (Houndmills, Basingstoke, St. Martin's Press, 2001), pp.49-75

38. Henry, Matthew, *Commentary on the Whole Bible Volume I (Genesis to Deuteronomy)* [Kindle]

39. Hess, Richard S., *Song of Songs, Baker* Commentary on the Old Testament Wisdom and Psalms, ed. by Tremper Longman III (Grand Rapids: Baker Academic, 2005)

40. Hickson, Rachel, *Release My Frozen Assets: A look at the role of women in the church* (Oxford: Heartcry Ministries, 2013)

41. Jhally, Sut (director) (1997). Dreamworlds II: desire, sex, power in music (Documentary). USA: Media Education Foundation

42. Johnson, Elizabeth A., 'Women's Place: Two conflicting views guide the church's position on women and have from the very beginning and therein lies hope', *Boston College Magazine* Summer 2004 http://bcm.bc.edu/issues/summer_2004/features.html [accessed: 27/03/2012]

43. Keener, C.S., 'Man and Woman', in *Dictionary of Paul and His Letters: A Compendium of Contemporary Biblical Scholarship*, eds. Gerald F. Hawthorne, Ralph P. Martin, Daniel G. Reid (Downers Grove: InterVarsity Press, 1993), pp.583-592

44. King, Ursula, *Religion and Gender* (Oxford: Blackwell Publishers, 1995)

45. Lee, Janet, 'Menarche and the (hetero)sexualization of the female body' (September 1994) in *Gender & Society*, Sage. 8 (3): 343–362.

46. Levy, Ariel, *Female chauvinist pigs: women and the rise of raunch culture* (London: Pocket Books 2006)

47. Luther, Martin. *Lectures on Genesis 3:11.*

48. MacKinnon, Catharine, *Only words* (Cambridge, Massachusetts: Harvard University Press, 1993)

49. Macnab, Geoffrey, *The Independent* (07/03/2018) < http://www.independent.co.uk/voices/jennifer-lawrence-red-sparrow-review-actor-film-decisions-cold-war-spy-thriller-a8244391.html> [accessed: 08/03/2018]

50. Mcleod, Hugh, *The Religious Crisis of the 1960s* (Oxford: Oxford University Press, 2007)McNeill, Patrick, *Research Methods 2nd Edition* (London: Routledge, 1990)

51. Miller Francisco, Grant, D., 'Ruether, Rosemary Radford', Boston Collaborative Encyclopedia of Western Theology (1999), <http://people.bu.edu/wwildman/bce/mwt_themes_908_ruether.htm> [accessed 02/02/2012]

52. Muers, Rachel, 'Feminism, Gender, and Theology' in *The Modern Theologians: An introduction to Christian Theology since 1918*, Eds., David F.Ford with Rachel Muers (Oxford: Blackwell Publishing Ltd., 2005), pp.431 – 450

53. Murphy R., and E. Huwiler *New International Biblical Commentary: Proverbs, Ecclesiastes, Song of Songs* (Peabody, MA: Hendrickson Publishers Inc., 1999)

54. Nee, Watchman, *The Song of Songs* (Alresford: Christian Literature Crusade, 1965)

55. Paul, Ian, Women and Authority: The Key Biblical Texts (Cambridge: Grove Books Limited, 2011)

56. Piper, John, *What's the Difference*, <http://cdn.desiringgod.org/website_uploads/documents/books/whats-the-difference.pdf?1414777989>

57. Provan, Iain, *The NIV Application Commentary: Ecclesiastes / Song of Songs* (Grand Rapids: Zondervan, 2001)

58. Pui-Lan, Kwok 'Mercy Amba Oduyoye and African Women's Theology', *Journal of Feminist Studies in Religion*, 20 no 1 Spring 2004, pp. 7-22.

59. Riss K. J. *God's word to women, Women in church History*, <http://www.godswordtowomen.org/rissjunia.htm>

60. Ruether, Rosemary Radford., *Sexism and God-talk*, (London: SCM press, 2002) 3rd edition

61. Schneiders, Sandra M., 'Feminist Hermeneutics' in *Hearing the New Testament: Strategies for Interpretation*, ed. Joel B. Green (Grand Rapids: Eerdmans, 1995), pp.349-369Segal E, *Who Has not made me a woman*, http://www.myjewishlearning.com/article/who-has-not-made-me-a-woman/

62. Schwab, George M., *The Song of Songs' Cautionary Message Concerning Human Love* (New York: Peter Lang Publishing Inc., 2002)

63. Shalit, Wendy, *A return to modesty: discovering the lost virtue*, (New York: Touchstone, 2000)

64. Shalit, Wendy, "Modesty revisited" in Orthodoxytoday.org. (2000) Fr. Johannes Jacobse http://www.orthodoxytoday.org/articles/ShalitModesty.php [accessed: 06/03/2018]

65. Slee, Nicola, *Faith and Feminism: An Introduction to Christian Feminist Theology* (London: Darton, Longman and Todd Ltd, 2003)

66. Spurgeon, C.H., *The Most Holy Place* (Fearn: Christian Focus Publications, 1996)

67. Szymanski, Dawn M., Lauren B. Moffitt, Erika R. Carr, 'Sexual Objectification of Women: Advances to Theory and Research 1ψ7'(22/09/2010) in *The Counselling Psychologist* < http://journals.sagepub.com/doi/pdf/10.1177/0011000010 378402> [accessed: 06/03/2019]

68. Tran, Robin, '4 ways men are taught to objectify women from birth' in *Everyday Feminism Magazine*, <https://everydayfeminism.com/2016/06/men-taught-to-objectify-women/> [accessed: 06/03/2018]

69. Weinrich, William, "Women in the History of the Church", in John Piper and Wayne Grudem (eds.), *Recovering Biblical Manhood and Womanhood*, (Crossway: 1991)

70. Wesley's John, notes on the Bible, 1 Cor. 14:34,35

71. Wilson-Kastner, Patricia, 'Christianity and New Feminist Religions', Religion-online database (09/09/1981), <http://www.religion-online.org/showarticle.asp?title=1722> [accessed 02/02/2012]

72. Woodhead, Linda, 'Spiritualising the Sacred: Critique of Feminist Theology', in *Modern Theology* 13, 2nd April 1997, pp.191-212

Richard Bradbury

About Richard Bradbury

Leading a church in Yorkshire and travelling to teach in India and Africa, Richard Bradbury's books arise out of the experience of 30 years of church leadership. Aiming to bring the truth of the Word of God to the wider Body of Christ, Richard writes in a no-nonsense, informed fashion approaching difficult doctrine head on with the aim of bringing clarity to the understanding of his readership. Married with four children and with a background in management alongside church leadership, Richard brings the benefit of the skills honed in all of these arenas to bear in his writing.

Books by Richard Bradbury

It's the End of the World as we know it (ISBN: 9780954551063)
This book has been written as a 'users guide' to the end times so that the reader can understand from the Bible the events leading up to the return of Christ in order that they may, when they 'see all these things, recognise that He is near, right at the door'.

Losing My Religion - The Radical Message of the Kingdom (ISBN: 9781907728174)
The Kingdom of God is the most important and fundamental doctrine in the Christian faith; everything else hangs off this truth and, unless we grasp this, we will miss the whole point of our faith. The hope of the author is that the reader will get hold of this same understanding and apply its implications to their own world.

Everybody Hurts - A Foray into the Minor Prophets (ISBN: 9781782284406)
The minor prophets are often neglected and rarely preached on. Perhaps we are frightened of prophetic texts or find them inaccessible, or perhaps we just can't see what relevance the 2000-year-old rantings of a bunch of dead men have in the 21st Century world. Journey through this book and see a present-day application, relevant for your life today.

The Great Beyond: restoring women to their God-given role in the church (ISBN: 9781782284574)
This book revisits the issue of women and church leadership. The author aims to shed fresh theological light on the arguments that have restricted the role women can play in the church. On the basis of theology, feminism and sociological research, this book provides a compelling case for removing all barriers for women with respect to ministry.